The Best of
Cahan Wilson

*"Do you ever catch yourself wondering if all this
is only part of some crazy experiment?"*

First Softcover Edition/October 2004 ISBN 1-887424-87-3
10 9 8 7 6 5 4 3 2 1

Underwood Books
P.O. Box 1919
Nevada City, CA 95959
www.underwoodbooks.com

THE BEST OF
Gahan Wilson

EDITED BY
CATHY FENNER AND ARNIE FENNER

UNDER WOOD BOOKS

NEVADA CITY, CA • 2004

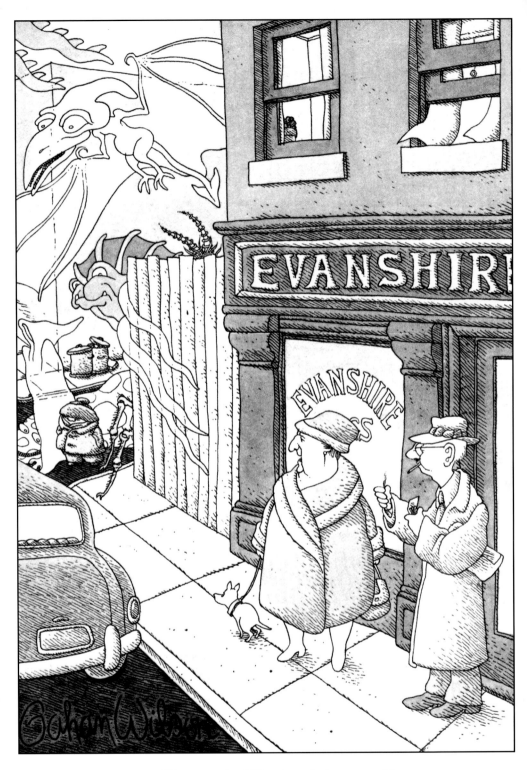

"*Here comes that Wilson boy–all alone as usual.*"

Here Comes That Wilson Boy...

By Arnie Fenner

The late Robert Bloch (forever remembered as the author of *Psycho*) used to delight audiences that had come to hear him speak at conventions and college campuses with an opening line meant to help explain his interest in horror and the supernatural: "I have the heart of a small boy. [pause] I keep it in a jar on my desk."

Gahan Wilson is a descendent of both showman/huckster P.T. Barnum and politician William

Gahan Wilson and pal. *Photo by Beth Gwinn.*

Jennings Bryan, but likes to credit at least part of the ghoulish path *his* 50-year career has followed with being born dead (on December 18, 1930). "The doctors had given my mother an anaesthetic, but instead of affecting her it put *me* out! So, I was stoned when I emerged, I wasn't breathing, getting bluer and bluer and the doctors weren't up to handling the emergency. Fortunately, the family doctor was looking in at all this going on and he dashed in and did this old-time thing of getting a bowl of hot water and a bowl of ice water, dipping me in one and then the other, whacking me in between, and that got me stirred to life."

Wilson grew up in Evanston, Illinois, a suburb of Chicago. "I was a creepy kid. I did the whole comic book thing, and then I discovered *Weird Tales**—I instantly homed right in on that around high school and just loved it. There really wasn't that much fantasy available in libraries and *Weird Tales* filled the gap. I really started with the science fiction pulps and then I spotted *Weird Tales* and went for that. One of the first things I did when I came to New York was to go to *Weird Tales* on the off-chance they'd take a little portfolio. I did get some drawings into *Weird Tales*. It was really in the nick of time, because the whole damn thing collapsed not long afterward.

"The Midwest is one of the creepiest places in the country," Wilson insists. "It denies it, but it's weird; really bizarre. I remember one Evanston widow who would run down the street at twilight in the summertime, decked out in a white turban with a flowing white robe. The traffic was considerably lighter than it is these days, so she'd run down the middle of the street with this horrified expression on her face. I mean she was really belting down the street. Then she'd pause and look back. You could see that whatever invisible threat she saw was gaining on her. Then she'd turn and run on. You'd just watch her...and

*A horror/fantasy pulp magazine produced from the 1920s to 1950s.

that was enough to creep you out, but somehow we never mentioned it to one another!

"There was a big mansion that had this high iron fence all around and there was this roadway that had roofing over it to protect the vehicles from the weather. By the curve of it was this pile of rubbish that was actually once a car, though you couldn't tell it. The woman who lived there had gotten married and, as they were getting ready to go off on their honeymoon, the groom went up to get the luggage, but suddenly died. So she just left everything the way it was the day he died and the car slowly turned into rusty sludge. Every once in awhile we would peer through the fence and all of a sudden there she was! Scared the *crap* out of us!

"Midwesterners are always in a state of denial. They won't admit it when things are weird, which is the reason why Ed Gein* got away with what he did. Kids would come back to their parents and describe these funny-looking masks Mr. Gein had. The only person that truly suspected anything was the sheriff. Everyone else looked at Gein as a harmless eccentric."

Wilson's interest in comics and a childhood spent drawing monsters led to his enrollment in the Art Institute of Chicago upon his graduation from high school. "Even though they didn't offer courses in cartooning—I was the first cartoonist to graduate—it gave me a good grounding in graphics and art. It was total no-nonsense work. We just drew and painted, painted and drew. That was a good move." After graduation he briefly served in the Air Force to fulfill his service requirement, but received an early honorable discharge because, "...I had a bad leg, which I thought was just fine and dandy because it got me out of it!"

*Serial killer who was the inspiration for *Psycho*.

In 1952 Wilson headed to Greenwich Village in New York to start his career. "I struggled," he remembers. "But it was a *fantastic* period! I hung out with all these painters and was accepted as a peer! At first, my parents gave me a little something to get by on. They told me they'd help out for six months—a few hundred dollars—so I got a dinky place. At the time there were lots of places to peddle cartoons, so I would sell to these fifth-rate markets. I went to these publishers who were imitating *True* magazine, as well as those *Ten Thousand Cartoons* mags, that kind of stuff. The rates would *just* get me by: they'd turn off the telephone, turn off the electricity, and then I'd earn enough to get them turned back on. I was barely living in this teeny apartment in a Greenwich Village slum building. My great moment of truth there was when I went over to the apartment of a pal of mine, a Japanese painter. We started hearing these angry noises from some woman and man next door: they kept hollering louder. Then they *really* started yelling at each other furiously; there were sounds of people stomping around and then this crash against the wall. Then there was silence. My friend looked at me and said, 'You know, it must be terrible, living like this, if you're ordinary people.' That's what Bohemia was all about! He nailed it!

Facing page: Gahan's famous cartoon for *Playboy*: "I think I won!"

"There's a very touching story about that cartoon," he says. "A lot of the soldiers in Vietnam apparently carried this cartoon with them. There were locals in Saigon, artists who would paint anything you wanted. A soldier had one of them paint a copy on silk and others saw it and had copies made and then more and more and they became quite in vogue. They'd carry these little silk flags like talismans into battle. I was terribly moved to hear that."

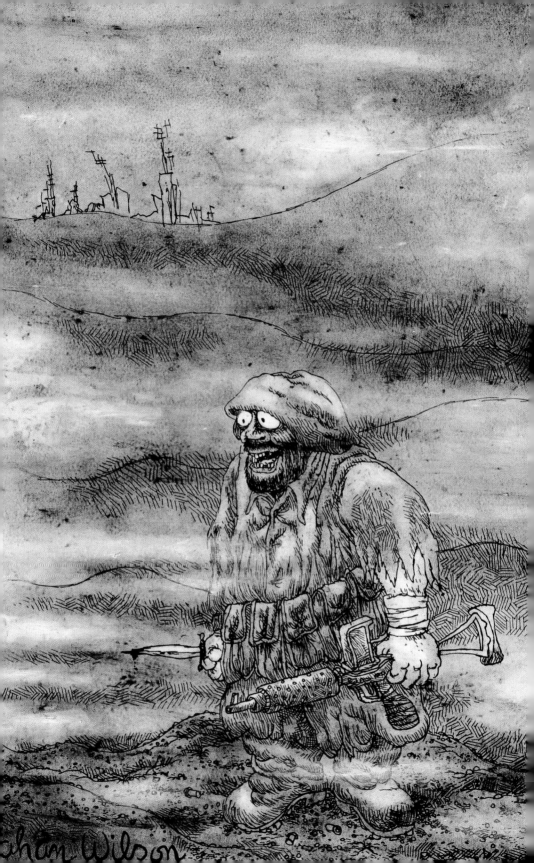

Today, artists—those poor bastards!—have to live in the outer boroughs because the rents in Manhattan are just out of the question."

Wilson struggled for several years before getting his big break into "the slicks." "When I'd make the rounds the editors at the various magazines would laugh and laugh and tell me how great my cartoons were. But then they'd

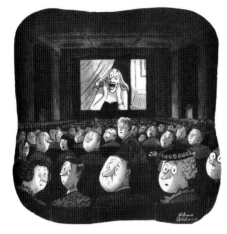

A cartoon from the *New Yorker* magazine by Charles Addams, whose *Addams Family* characters were adapted for a TV series and several films.

"I loved Addams' early work," Gahan says. "His universe was so neat and carefully structured and the horrible events in his cartoons were startlingly contrasts. The loathsome monster appearing in the tidily-drawn, tidy room was very effective."

say, 'Kid, you really are funny! It's swell stuff, but our readers really wouldn't understand these things.' My material was really very far out for the time, so that was the response I kept getting. Then the cartoon editor at *Collier's*—which was a very prestigious market—quit and took the job of cartoon editor at *Look* magazine. In the meantime, before they found a replacement editor, they had their art editor Bill Chessman filling in temporarily. It was a fantastically lucky break for me because Bill didn't understand that I was 'too much' for the common people out there and he bought my cartoons. They were published, people liked them, and when the cartoon editor who'd moved to *Look* saw them in *Collier's*, I guess he realized the world had-

n't come to an end or anything like that, so he started buying from me. I may have never been successful if Bill Chessman hadn't gotten the ball rolling."

That ball continued to roll and pick up speed as Wilson added to his list of A-list clients: the *New Yorker*, *The Magazine of Fantasy and Science Fiction*, *Help!*, and, quite accidentally, *Playboy*.

"A new magazine had appeared on the stands called *Trump*," Gahan remembers, "and it was a super-classy production version of *Mad* which had as its editor Harvey Kurtzman, *Mad's* own creator, snatched from Bill Gaines.* I didn't know Harvey personally at that point, but I had always liked his approach and I figured I might be able to tie in with him. Since *Trump's* masthead listed offices in Chicago and I had planned to visit my parents in Evanston for Christmas anyway, I made an appointment and took my portfolio to the Chicago address when I had gotten into town.

"The place turned out to be a little brownstone in the Near North Side and they told me that

Wilson's first book, published by Ace in 1965.

Trump wasn't in Chicago after all, but in New York. I was about to leave, feeling understandably a bit of a simp, when a fel-

*Legendary publisher of EC Comics and *Mad* magazine.

low came down the narrow stairs and said, 'Hi, I'm Art Paul: Hef wants to see you.' I didn't know who Art Paul was and I didn't know what a 'Hef' was, but okay, fine, I'll see 'Hef.' So I followed him upstairs to a small dark room where there was a lean, dark man talking on the telephone.

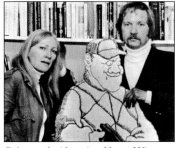

Gahan and wife, writer Nancy Winters, flanking one of his characters, 1973.

And–I'll never forget it–he said to the person on the other end of the line, 'Well, I

think it's a very good article. I think it's well written and I liked it. But...it's anti-sin and I'm afraid we're *pro-sin.*' Then he hung up, reached a hand out to shake mine, gave that sudden grin which is

Gahan's cover for *The Magazine of Fantasy & Science Fiction* [January, 1969] illustrating the short story "Santa Claus vs. S.P.I.D.E.R" by Harlan Ellison.

now world famous, and said, 'I've been waiting to see you!' So my getting into *Collier's* was a fluke and my getting into *Playboy* was a fluke."

Wilson's unexpected meeting with Hugh Hefner turned out to be perhaps the most important "fluke" of his career. With Hefner's and his editors' encouragement he was able to let his imagination run rampant in both color and black and white; it can be persuasively argued that the majority of Gahan's best work has appeared in *Playboy* throughout the course of their 50 year relationship. Many readers have said

that Wilson's monthly cartoon was their *second* favorite regular feature in the magazine.

He also developed a long-term association with *The Magazine of Fantasy & Science Fiction*, acting as their exclusive cartoonist for three decades. "I did all kinds of stuff, actually," Gahan recalls. "I did covers and stories; I really started writing then. I also worked with *F&SF's* editor, Ed Ferman, on a magazine called *P.S.* It was an interesting idea, not quite a nostalgia magazine, but an examination of all kinds of stuff. It lasted about six issues, but I got to do a whole bunch of fun stuff. I did an interview with

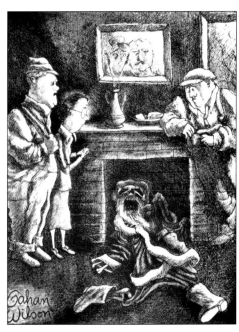

Gahan's classic 1965 cartoon for *Playboy*: "Well, we found out what's been clogging your chimney since last December, Miss Emmy." This grim bit of holiday cheer was translated into a childhood trauma described by actress Phoebe Cates in the 1984 Joe Dante film, *Gremlins.*

Rex Stout about Nero Wolfe: I had a wonderful day. I asked him all these questions

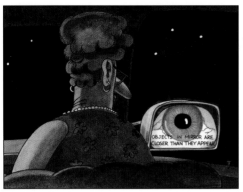

Just as Addams had influenced him, Wilson was an influence on Gary Larson's wildly popular newspaper cartoon, *The Far Side*. In *The Pre-History of The Far Side* Larson credits his career choice to, "...an interest in *Mad* magazine during my adolescence, and an appreciation for Gahan Wilson's work in *Playboy*."

nobody had ever asked him before. Every once in awhile I'll see a quote about Nero Wolfe and notice it came from my interview."

Admired by readers of the *New Yorker* and a favorite of subscribers to *Playboy* as well as the SF fans of *F&SF*, Gahan also found a home in the pages of the counter-culture's flagship humor magazine, *National Lampoon*. He had done various pieces for *Playboy* that featured thematically-linked cartoons, but it was for the *Lampoon* that he experimented with illustrated essays that showcased the range and depth of his writing talent. Like one of Gahan's more memorable cartoons "nothing was sacred" at the *NatLamp* and as a matter of routine they made fun of virtually anything they could think of. His pieces were simultaneously pessimistic, brutal, and hysterically funny. "The *Lampoon* was a wonderful magazine," Wilson says. "It was very casual and free. I think it's a damn

shame that there is no equivalent these days. We had a great time! I think it's very possible that we're heading for an era that might be very conducive for a magazine like *National Lampoon* again." Gahan also created the monthly comic strip *Nuts* for them, which alternated between being a sentimentally nostalgic reflection on childhood and a sharp-edged bit of social commentary.

Over the years Wilson has expanded his interest in horror and fantasy by writing a novel (*Eddy Deco's Last Caper*, 1987), short stories (collected in *The Cleft and Other Odd Tales*, 1998) and film and book reviews (for *Twilight Zone Magazine* and *Realms of Fantasy*). He was one of the founders of the annual World Fantasy Convention (started in 1975) for which Gahan designed and sculpted the bust of writer H.P. Lovecraft that serves as the convention's award. He's had disappointing flirtations with Hollywood and has created art for limited edition lithographs—all while continuing to create bitingly witty cartoons for a variety of clients.

It's pointless to try and explain why one thing is funny and another isn't: analyzing humor is a sure way to ruin the joke. There's irony and cynicism in Wilson's cartoons: he gleefully pokes fun at politicians and religion and the conventions of society with a black humor that can be as disturbing on reflection as it is funny. It's often said that an artist's work should speak for itself, and in Gahan's case, that adage is especially true. Best to sit back and let Gahan Wilson's mix of hard-edged truth and youthful innocence surprise and shock the laughs out of you. And, if you must have a reason why his work is so memorable, figure that it's because, like Bob Bloch, Gahan has the heart of a young boy: he keeps it in a jar on his drawing table. †

THE BEST OF
CAHAN WILSON

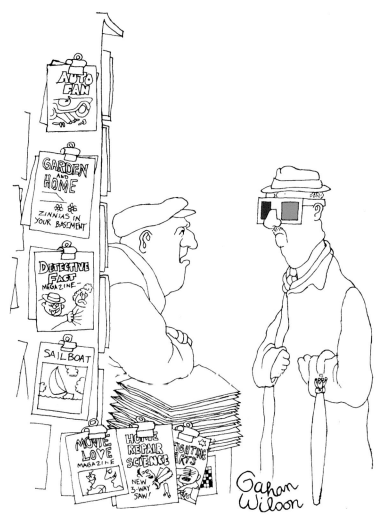

*"How many times do I have to tell you, mister?
We don't carry 3-D comics anymore."*

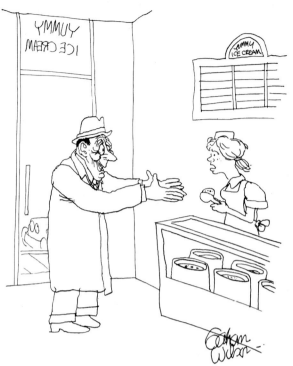

"In your bare hands, as usual, Mr. Rodgers?"

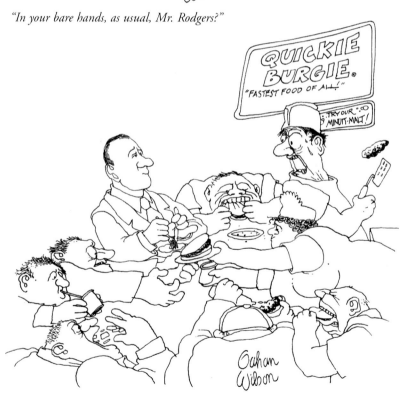

"For God's sake, man—do your part and bolt the stuff down!"

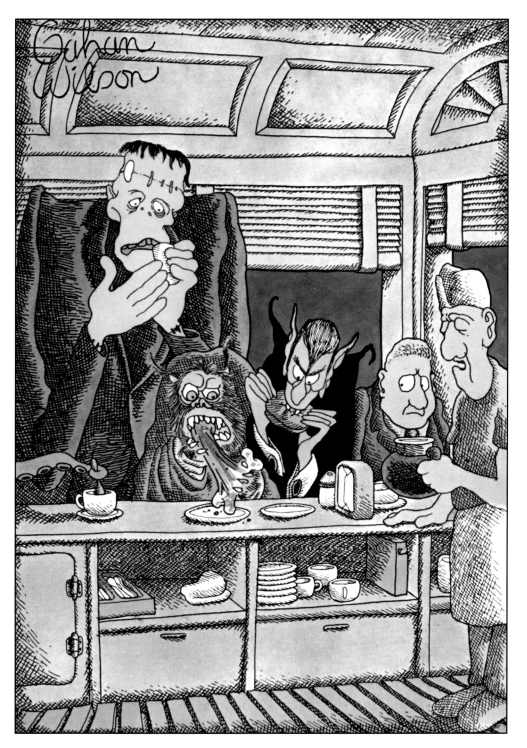

"It's the kind of trade you get in a twenty-four-hour-a-day joint."

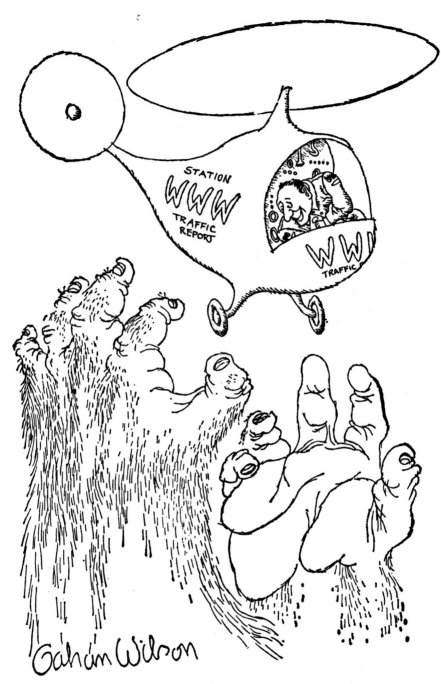

"I think we've located the cause of that tie-up at
Thirty-fourth Street and Seventh Avenue!"

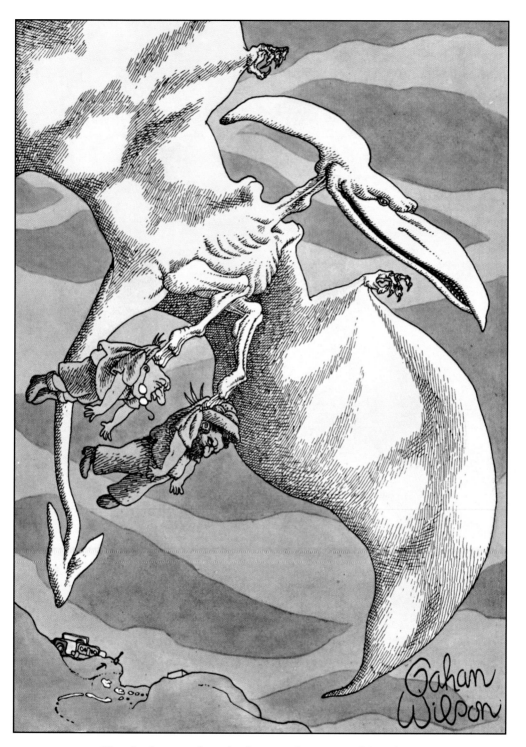

"I'm afraid our expedition has been a trifle too successful, professor."

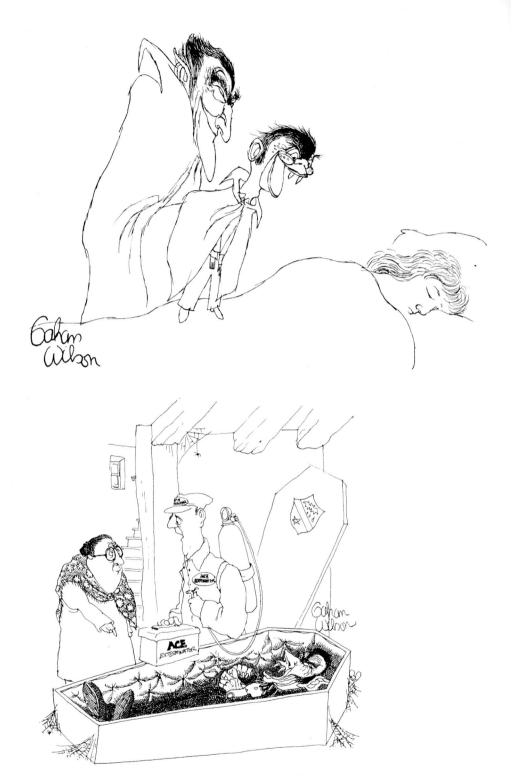

"I am sorry, ma'am, but this is really very much out of my line."

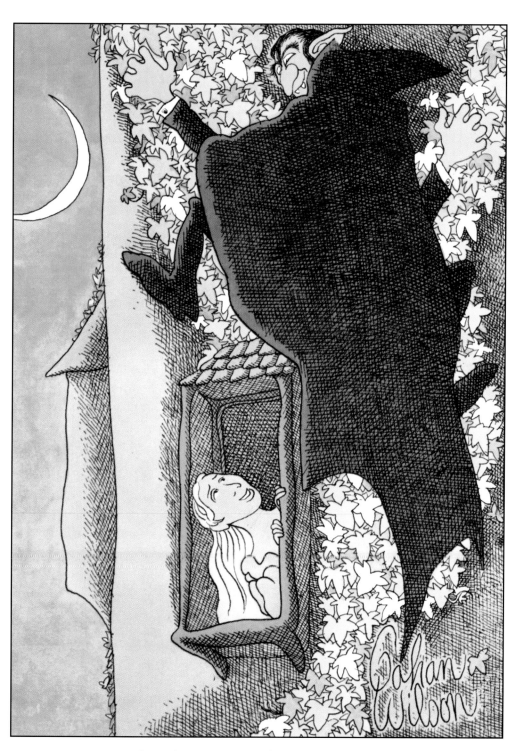

"Don't be a stranger, now that you know the way!"

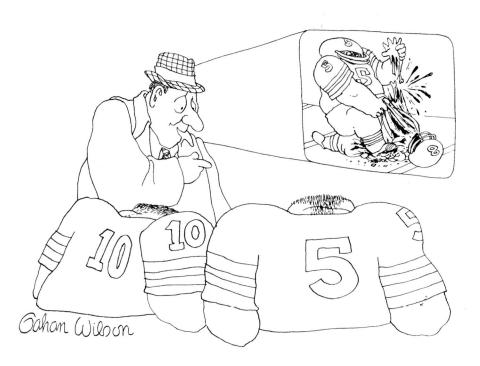

"See that, Stanley? That's the kind of thing I want you to avoid!"

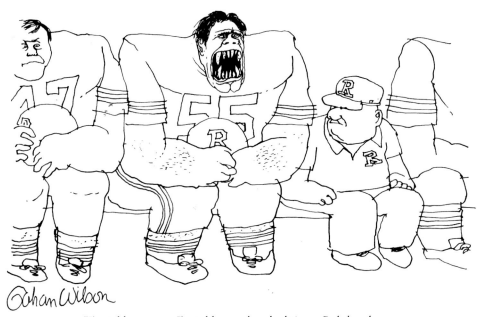

*"I've told you once, I've told you a hundred times, Bukchneck,
keep your mouth closed!"*

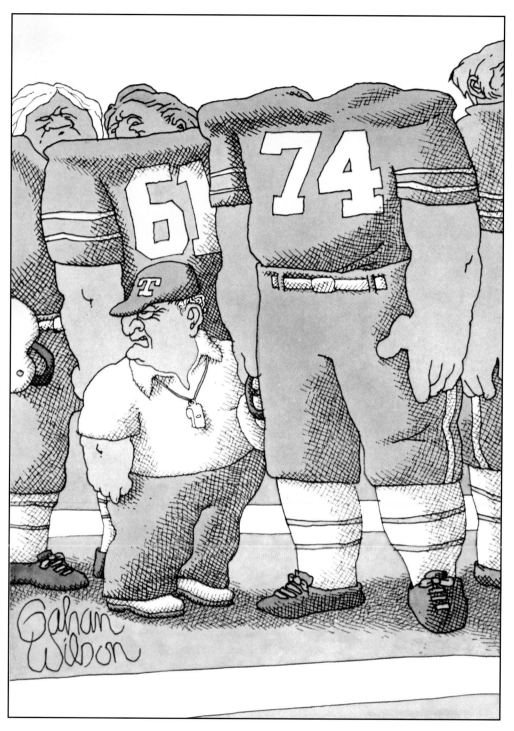

"Anyone here seen Swazee's head?"

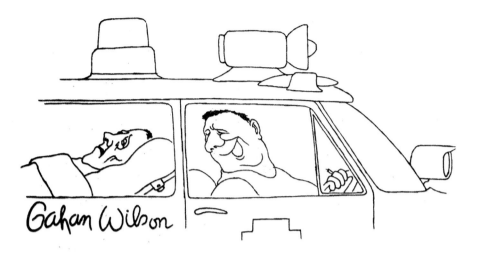

"Like to see what this baby can do?"

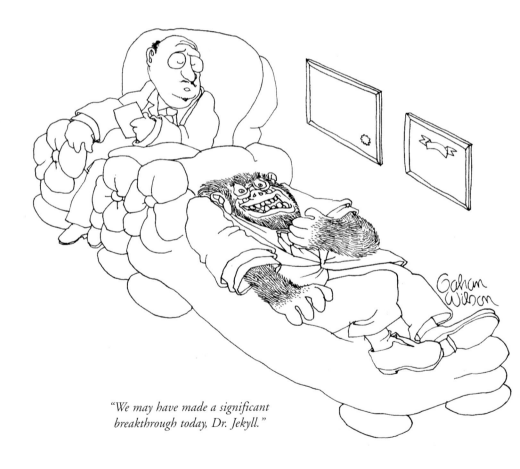

"We may have made a significant breakthrough today, Dr. Jekyll."

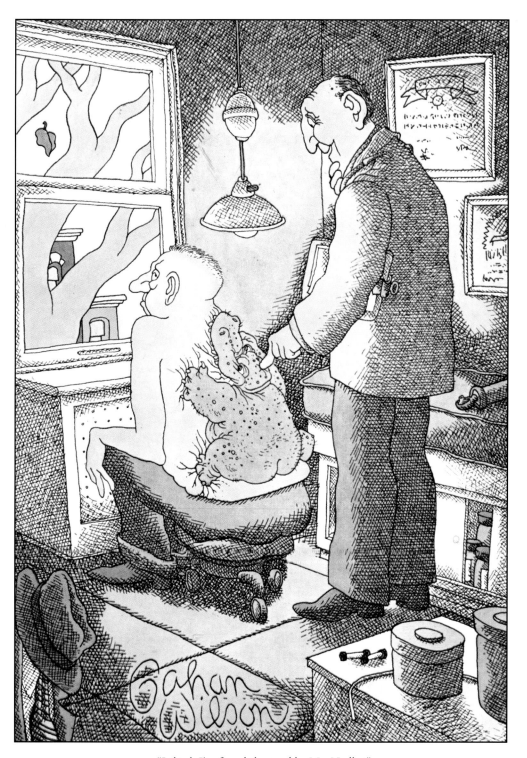

"I think I've found the trouble, Mr. Nadler!"

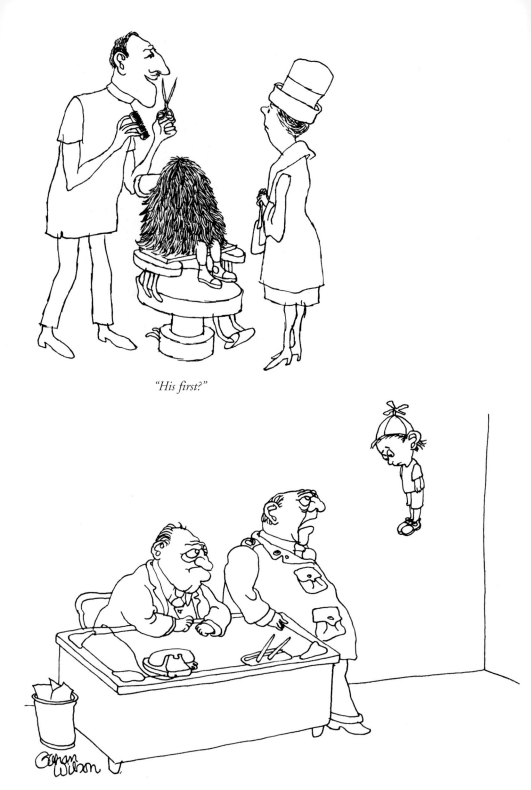

"His first?"

"Sorry, son, but from now on you're classified."

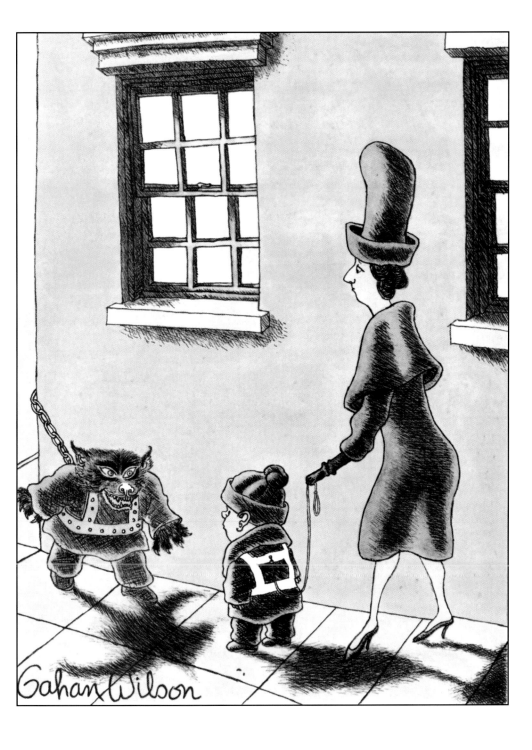

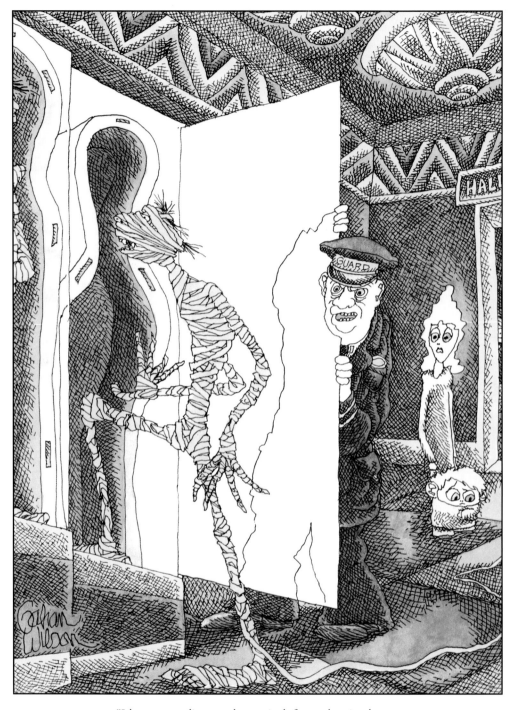

*"I hope you realize your late arrivals for work seriously upset
the museum's visitors!"*

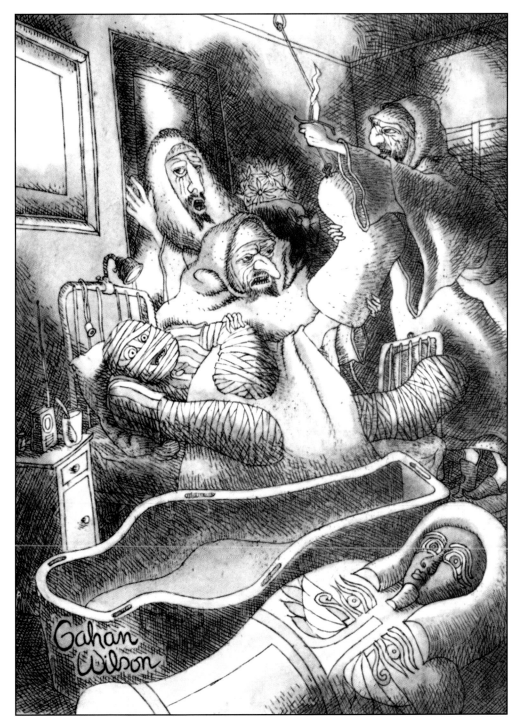

"I tell you guys, you're making a horrible mistake!"

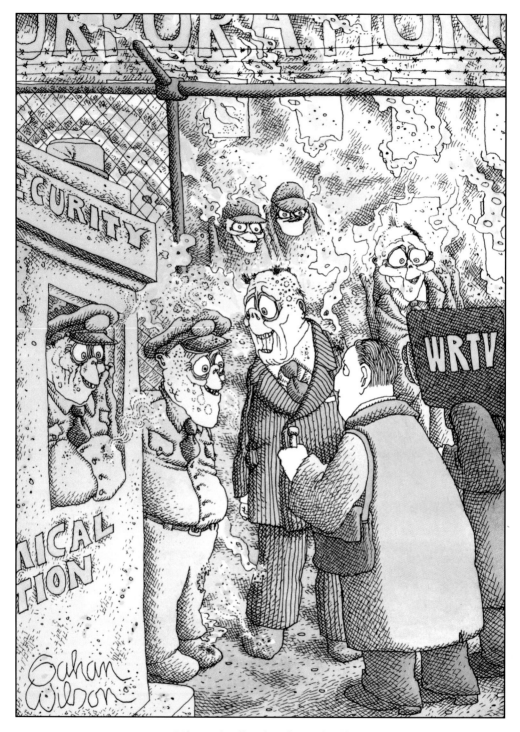

"Chemical spill? What chemical spill?
Anybody here know anything about a chemical spill?

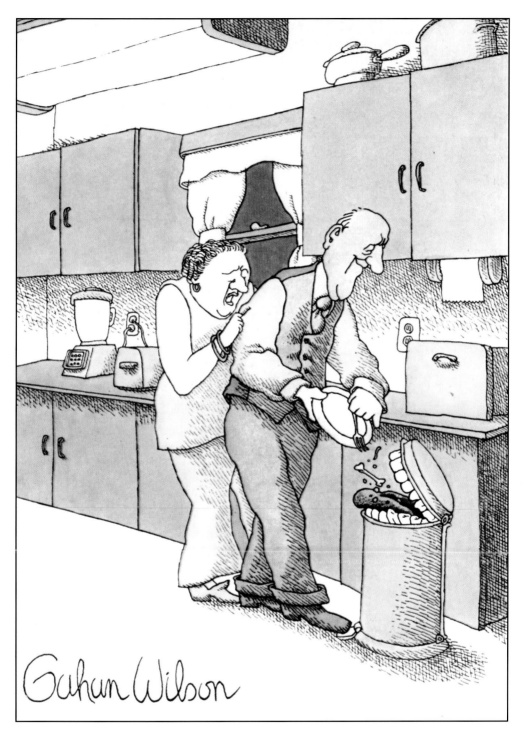

"Oh, Irwin, I wish to God you'd get rid of that thing!"

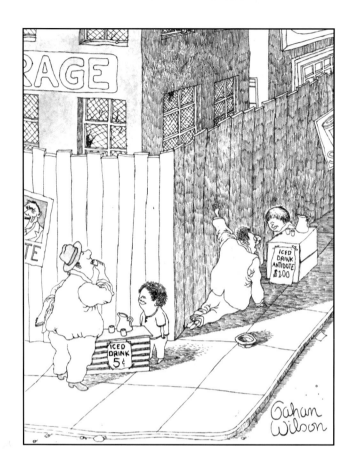

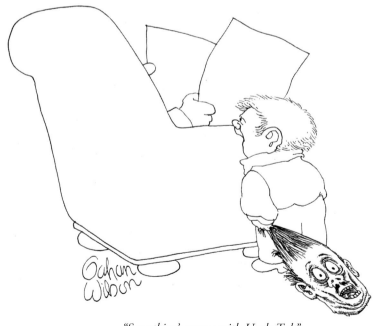

"Something's wrong with Uncle Ted."

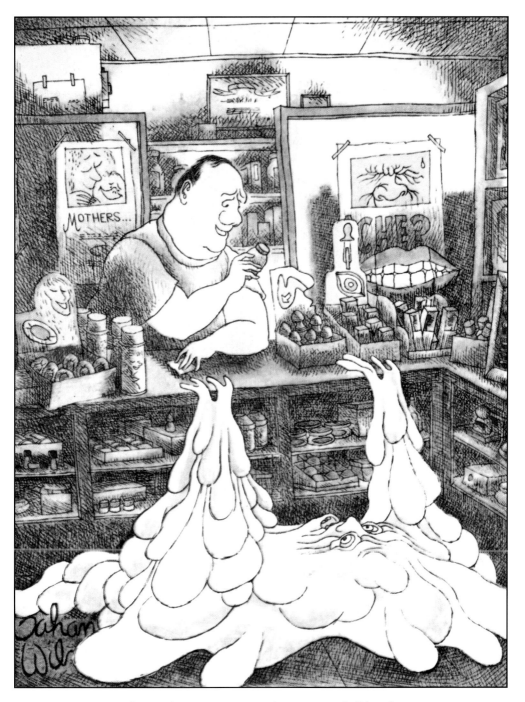

*"My goodness, Mr. Merryweather, we certainly did make
a boo-boo with that prescription of yours!"*

"I'm sorry, madam, but these units are for display purposes only."

"And every day it's costing more and more!"

"Harvey! *You come down here this* instant!!"

"Do you really believe in any of this stuff?"

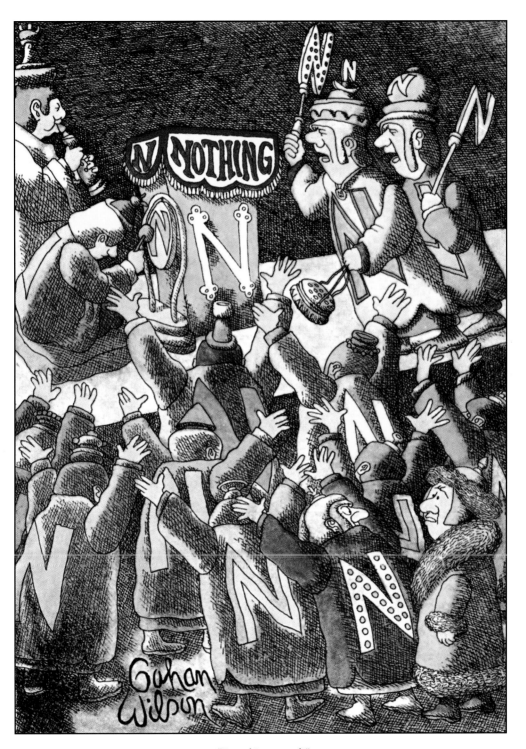

"Is nothing sacred?"

"Why aren't you out there protecting us from evildoers, young man?"

"It's a little something I'm calling The Book of Revelations!*"*

"What I always say is–don't get involved!"

"Somehow I thought the whole thing would be a lot classier!"

"My husband, of course, will want a den."

*"I'm afraid this simulator test indicates Commodore
Brent would be a poor choice for the Lunar Expedition."*

"Well, I guess that's the last time the Cullings ever invite us over!"

"No fair turning yourself off, Mr. Hasbrow!"

"Oh, yes, and that's another thing, Mrs. Salzman. Don't do that anymore to Mr. Salzman."

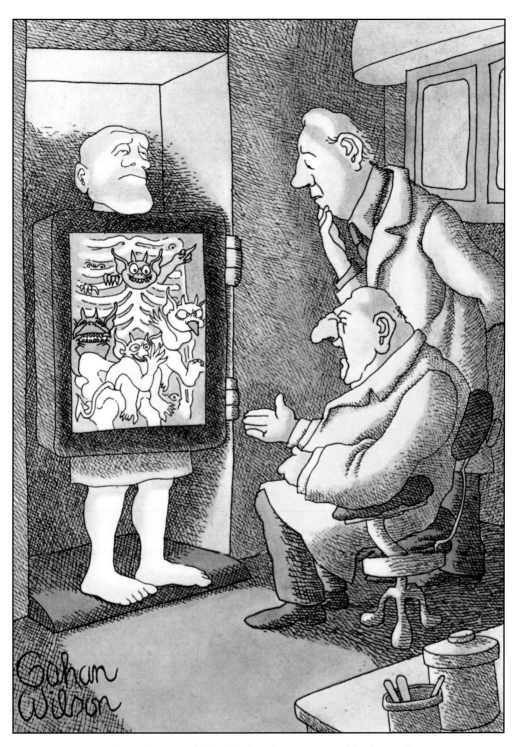

"It's as I suspected–Mr. Harding, here, is possessed by demons."

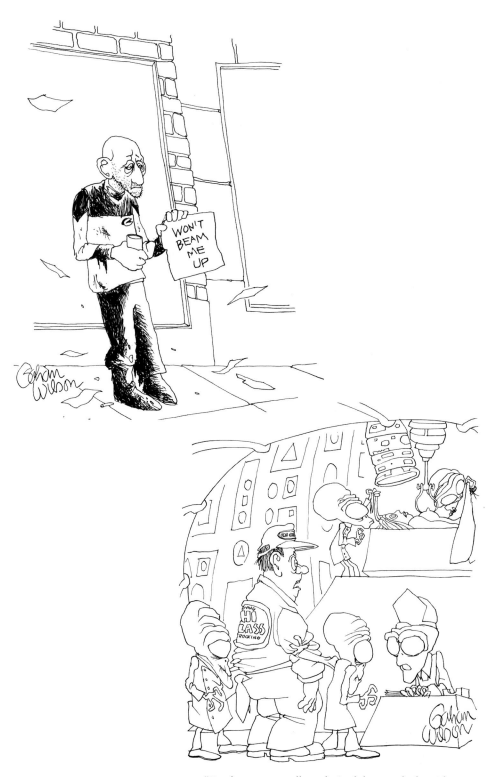

*"You know very well we don't abduct anybody without
full medical coverage!"*

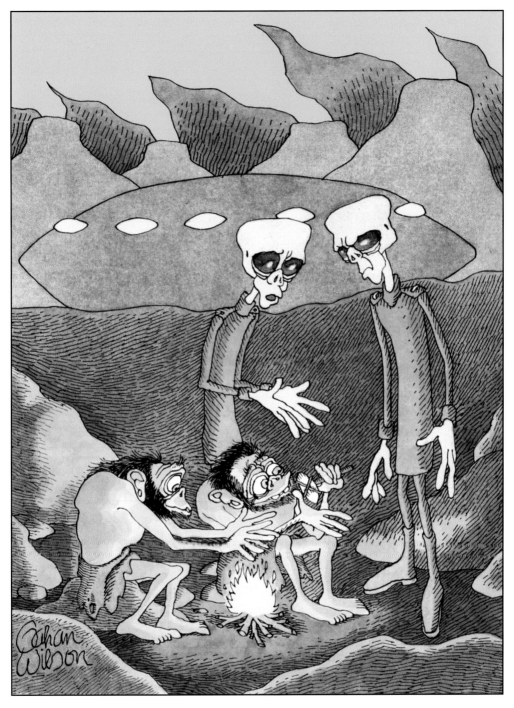

"What possible harm can come to this planet from teaching these miserable creatures how to use fire and simple tools?"

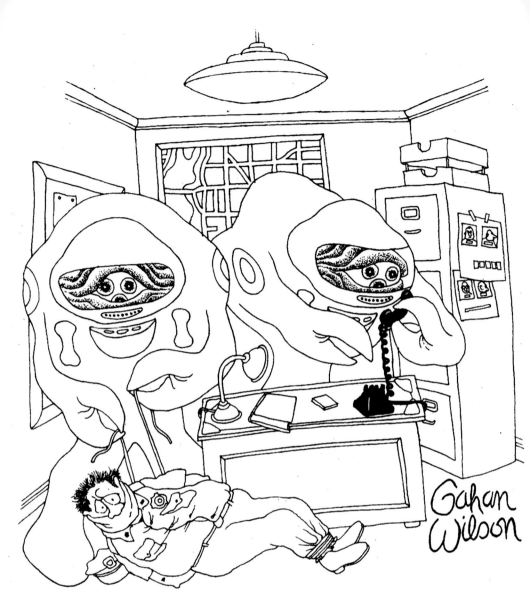

"We've heard the rumors, ma'am—there's absolutely nothing to them."

"I'm afraid they've decided to stop kidding around!"

"Thank God!"

*"Hold it, Newton. We've been
barking up the wrong tree."*

"Must you bring that up every time we have an argument?"

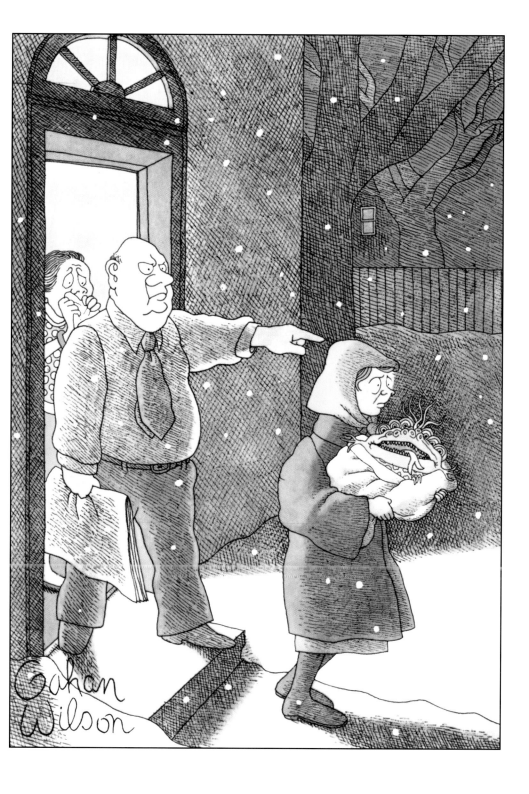

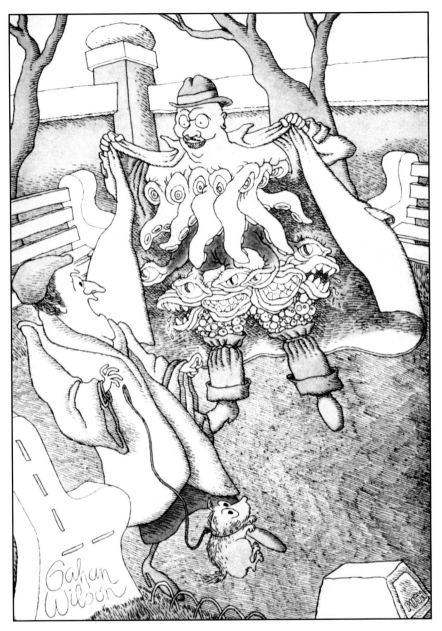

"A lot of the *Playboy* cartoons are an absolute homage to Lovecraft's stuff. In one, a flasher spreads his tacky raincoat and horrifies a little old lady and her dog in a park, and he's not exposing human anatomy—the knowledgeable would know it was Wilbur Whateley of 'The Dunwich Horror.' "

—*Gahan Wilson*

Collection, 1973

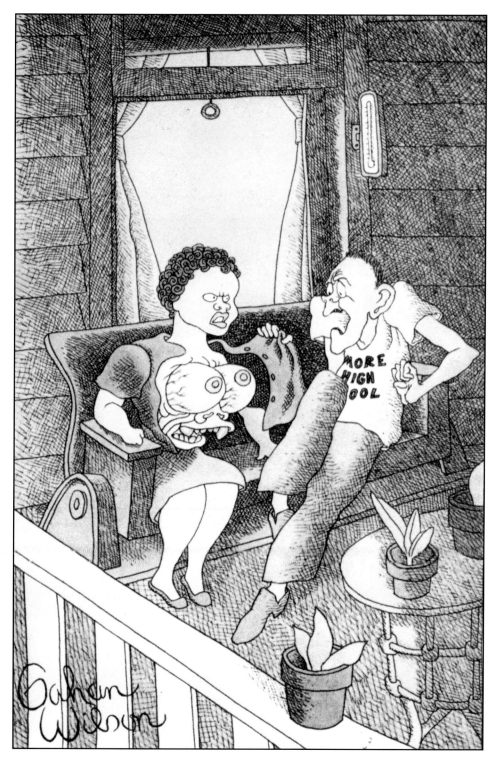

"I told you not to do that!"

"Beastly sorry about all these interruptions."

*"Now that you've come of age, son, I think it's time your old dad
let you in on our little family curse."*

*"Sorry I'm not making myself clearer, but it's hard to express yourself
in a language as crude and primitive as ours."*

*"I'd say it's a pretty obvious case of evolution taking
a wrong turn."*

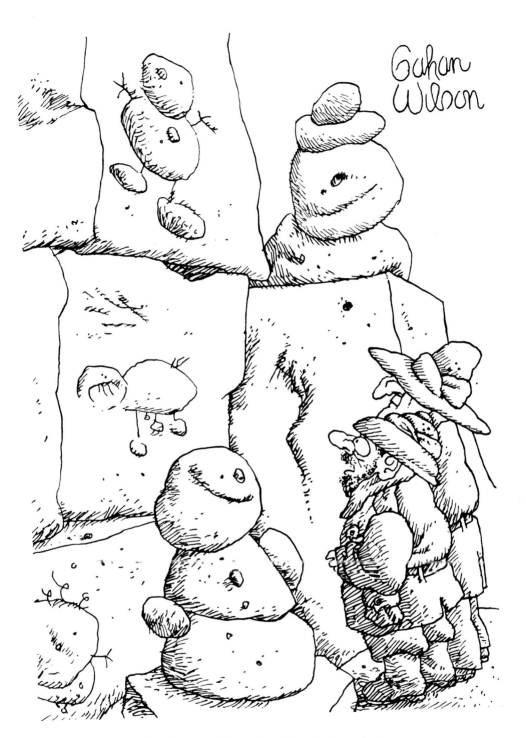

"I don't know, Professor; this civilization is so primitive,
it hardly seems worth our time!"

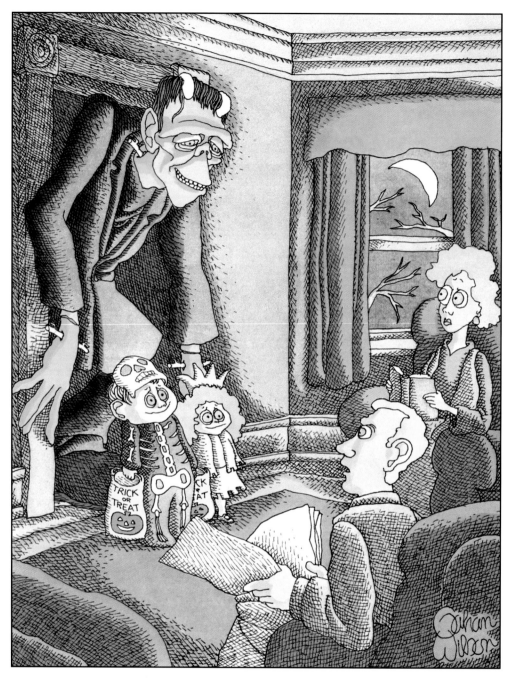

"I don't care if he did follow you home—you can't keep him!"

"I recently came across some drawings saved by my parents done when I was a tiny kid—and even back then I was drawing skeletons, space ships, etc.—and on one of the drawings, written in my mother's loving hand, it says: HORRIBLE MONSTER COMES TO KILL US ALL."

—*Gahan Wilson*

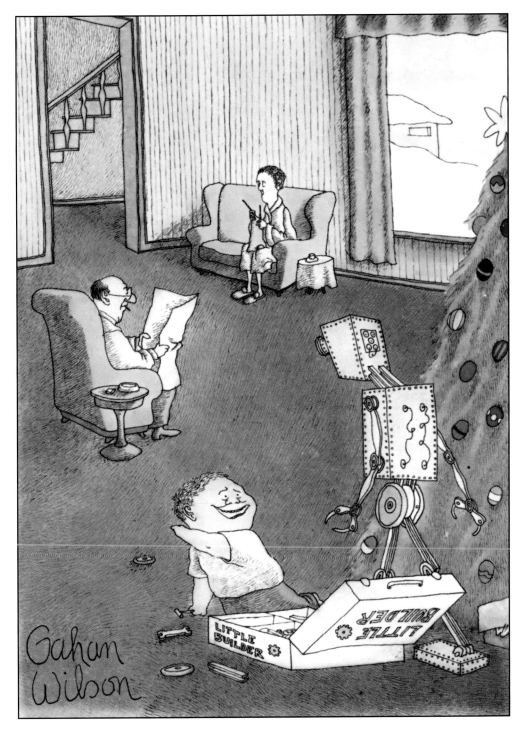

"Kill!"

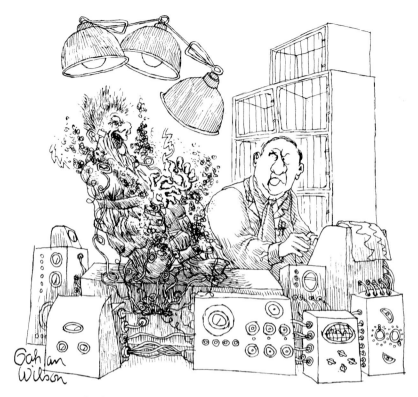

*"Oh, shut up, Johnson. We'll go back to using puppies
the second they send us some more!"*

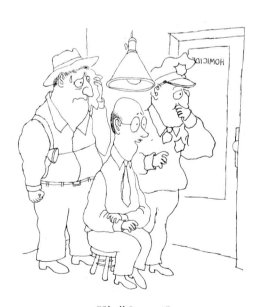

"Shall I go on?"

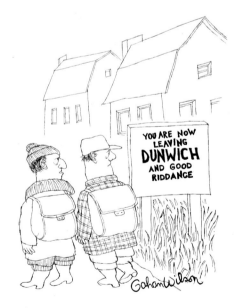

*"They certainly don't take kindly to strangers
hereabouts."*

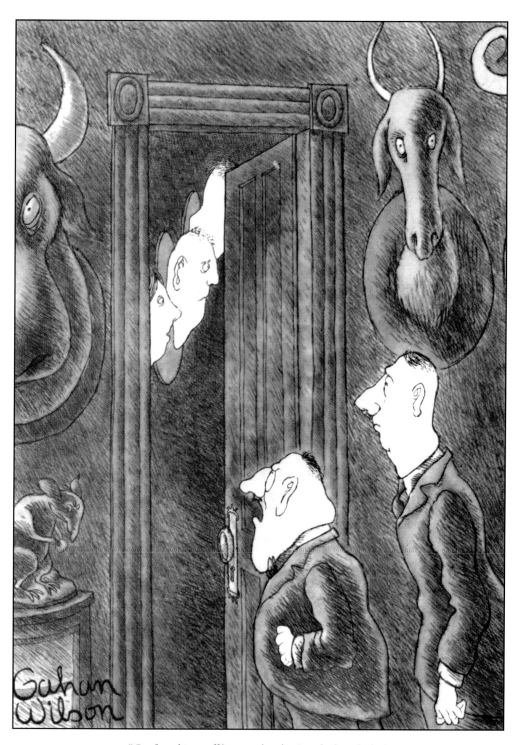

"Confound it, staff knows this door's to be kept locked!"

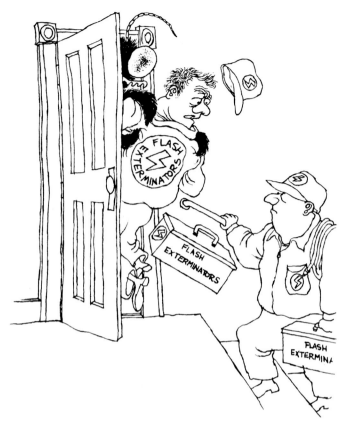

"Ed! Run! It's a trap!"

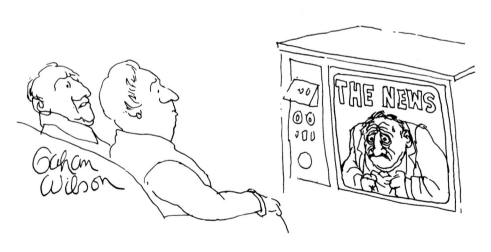

"My God—it must really be bad tonight!"

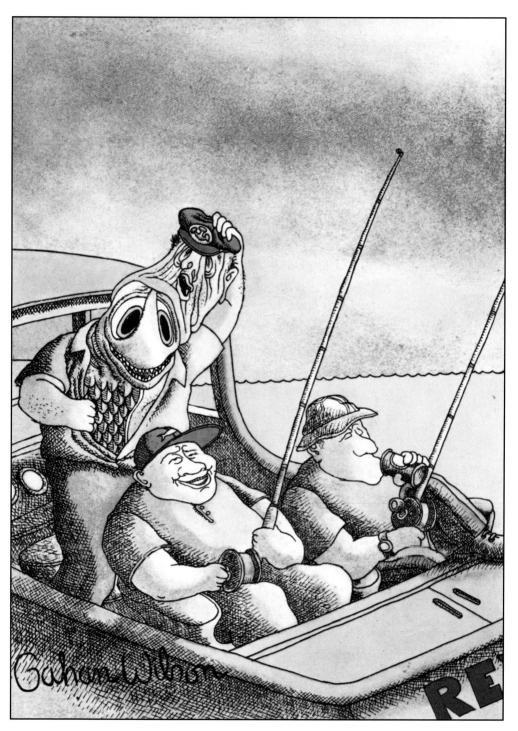

"How did you come to name your boat the Revenge, Captain?"

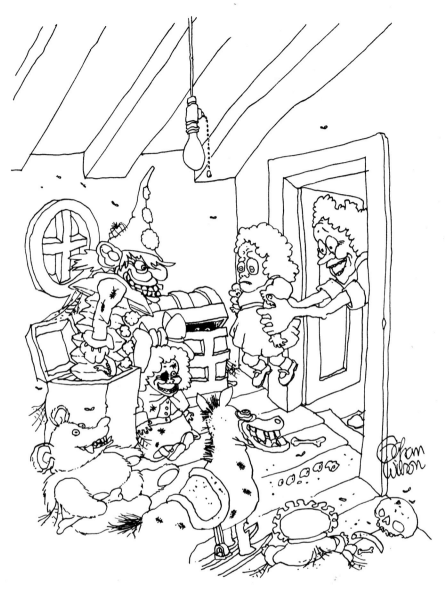

"Here's someone new for you to play with!"

"In a puritan society such as ours, if you do humor or horror in any artistic thing, it is automatically considered to be less than if it's 'serious.' If it doesn't scare you and it doesn't make you laugh, it's 'serious.' If the artist gets scary or he gets silly, the critical tendency is to say, 'That's a minor work.' So it was a bitch for Edgar Allan Poe or Mark Twain to get serious recognition. They finally managed to do it, because they did some of the best stuff around, but it was an uphill struggle."

—*Gahan Wilson*

Collection, 1978

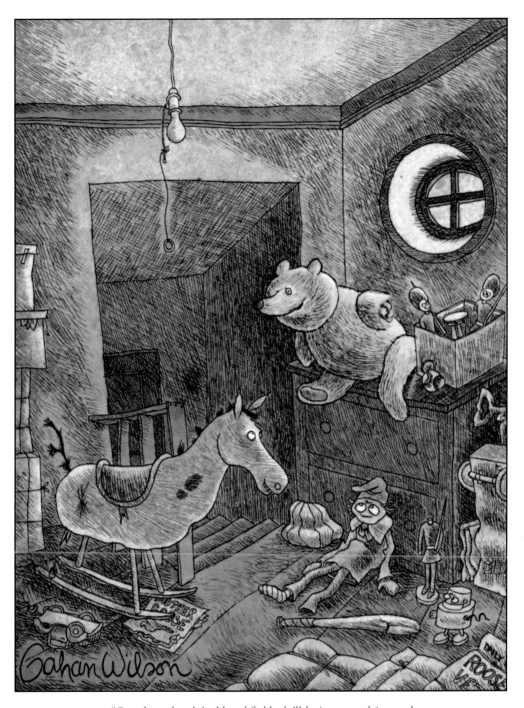

*"One day, when he's old and feeble, he'll be in a nostalgic mood,
and he'll come up here to see us again, and to reminisce—
and then we'll get him!"*

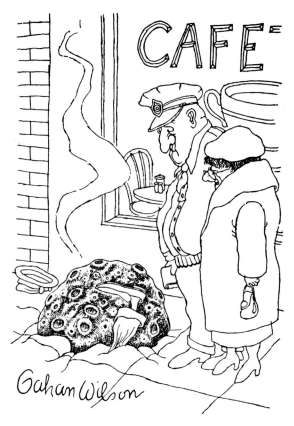

"Funny thing. Eddie was always sure a meteor would get him."

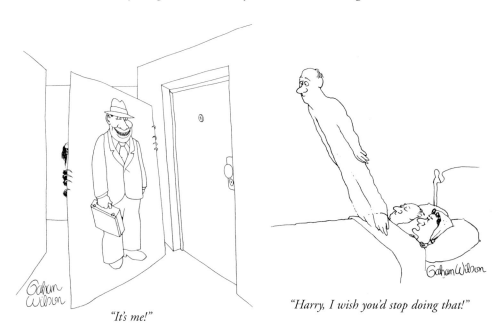

"It's me!"

"Harry, I wish you'd stop doing that!"

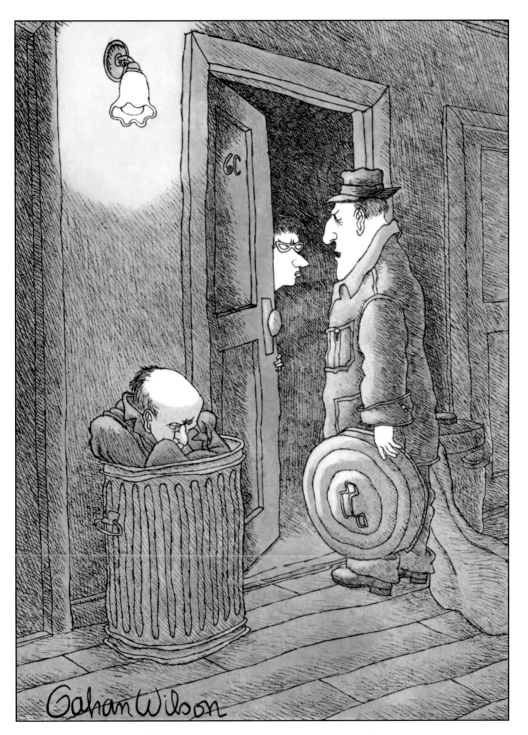

"You don't get rid of him that easy, Mrs. Jacowsky."

"...But suppose the enemy doesn't scare easily?"

"Gives the men no end of confidence."

"Looks like the end of civilization as they know it."

"Very well, Carter, you've proven my theory faulty–let it go at that!"

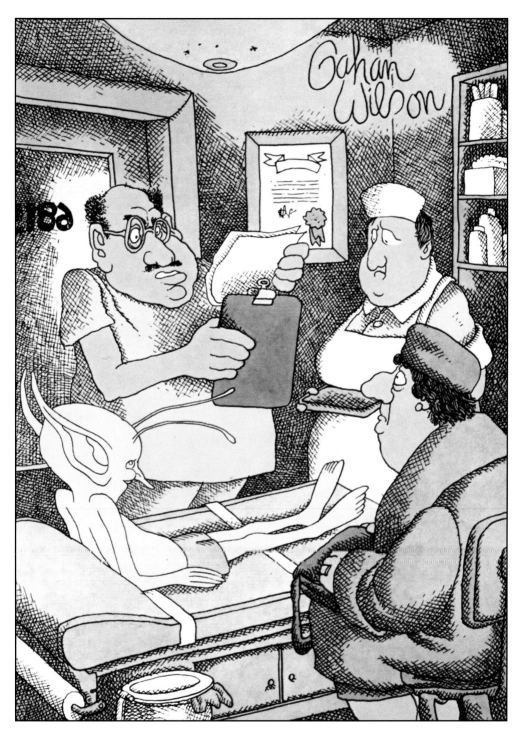

"I'm sorry, Mrs. Smith, but our tests show your child
is a changeling left by fairies."

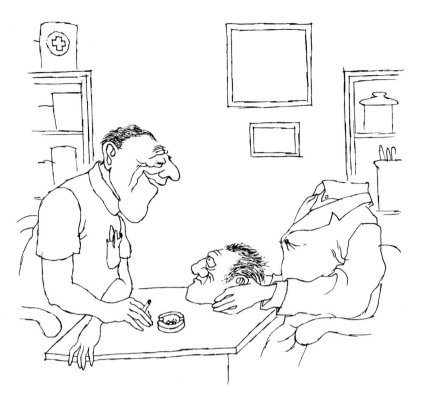

"Well, now—what seems to be the trouble?"

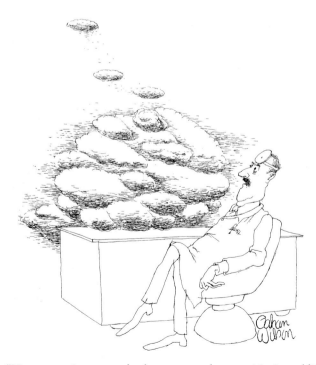

"How many cigarettes a day have you got down to, Mr. Leopold?"

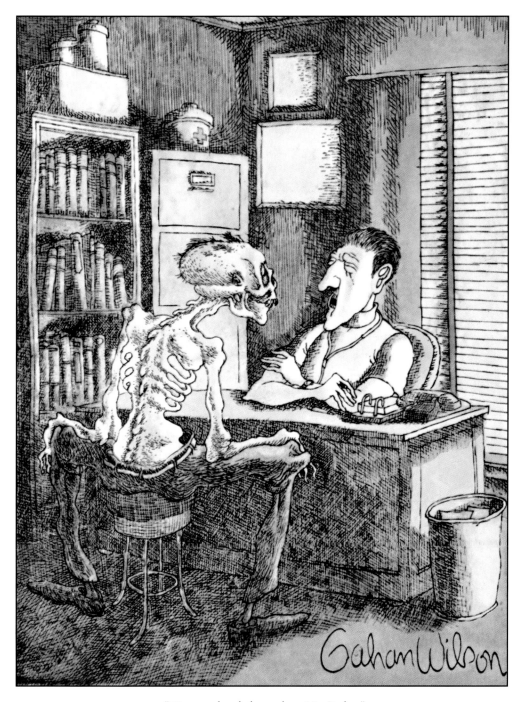

"We may already be too late, Mr. Parker."

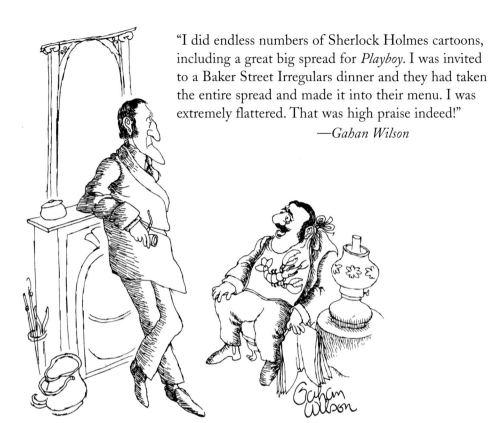

"I did endless numbers of Sherlock Holmes cartoons, including a great big spread for *Playboy*. I was invited to a Baker Street Irregulars dinner and they had taken the entire spread and made it into their menu. I was extremely flattered. That was high praise indeed!"
—*Gahan Wilson*

"Good lord, Holmes! How did you come to know I'd seafood for lunch?"

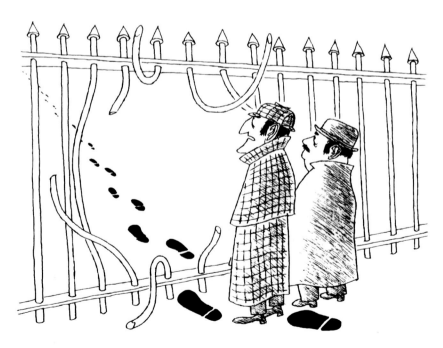

"Perhaps we'd best wait for Inspector Lestrade."

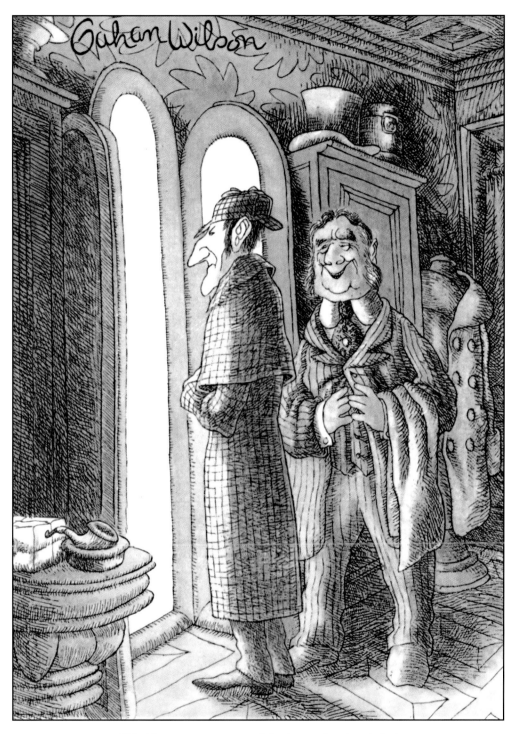

"Would you care to step out of the shop and see how it looks in the fog, Mr. Holmes?"

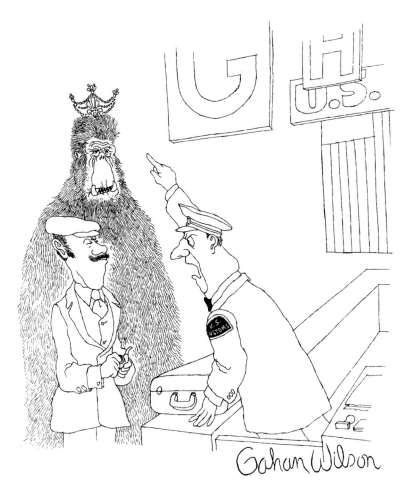

"I'm not talking about your Abominable Snowman, mister—I'm talking about that diamond tiara!"

"There's another one of those abominable mountain climbers."

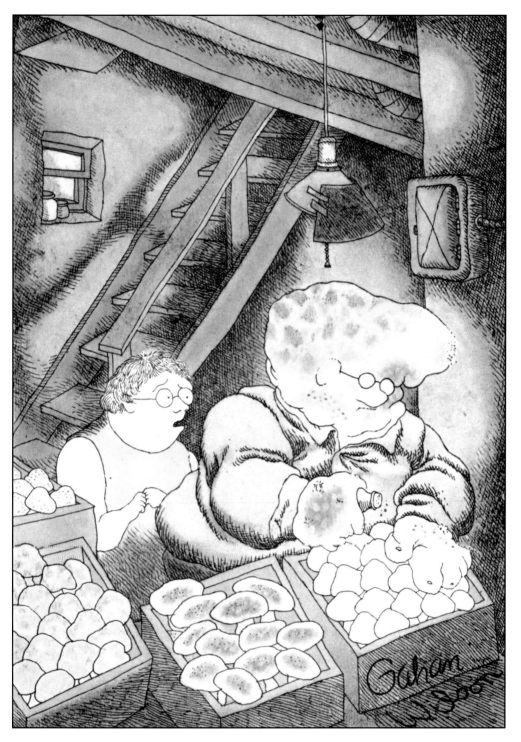

*"Fred, I think you're spending altogether too much time
down here with these mushrooms!"*

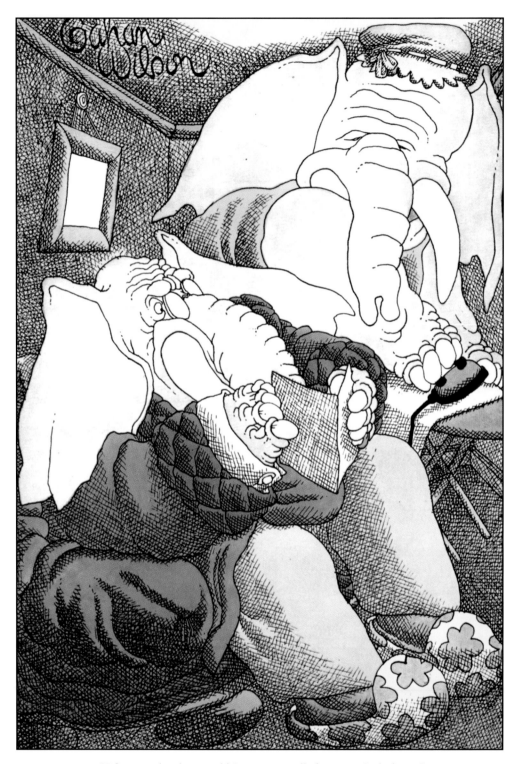

"Of course, the place wouldn't seem so small if we weren't elephants."

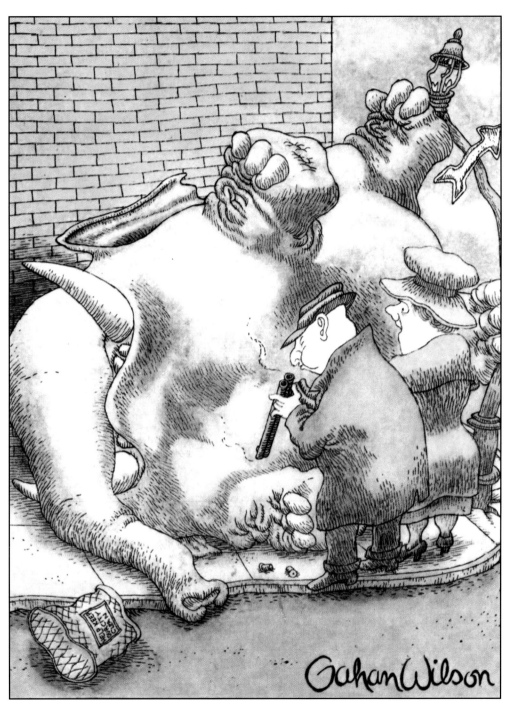

*"Honestly, Harry, I'll never tease you again for
carrying around that elephant gun!"*

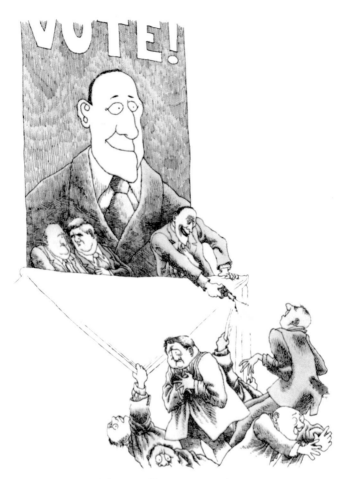

"This is really quite a switch!"

"I'm sorry, Senator, it's some more of those crackpot conservationists."

"We really are having awful luck on this trip!"

"You never know when he'll fall off the wagon."

"There's an amusing little legend connected with that..."

"Sir! The Moorne Castle Monster is under the strict protection of the National Historical Trust!"

"I don't suppose it ever crosses their minds how hard it is to clean up after them!"

"It's disgusting how they'll commercialize anything!"

*"Don't get it wrong, Bridget—the sacrifice of a white rooster
every third day at precisely high noon without fail!"*

"Turn the pages one at a time, *stupid!"*

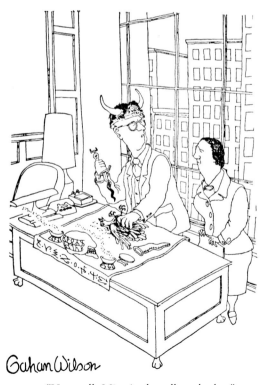

"Very well, Miss Apple—call my broker."

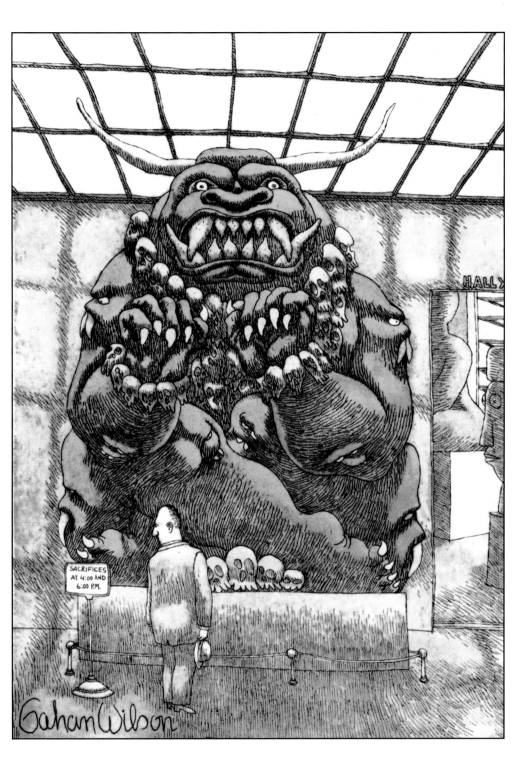

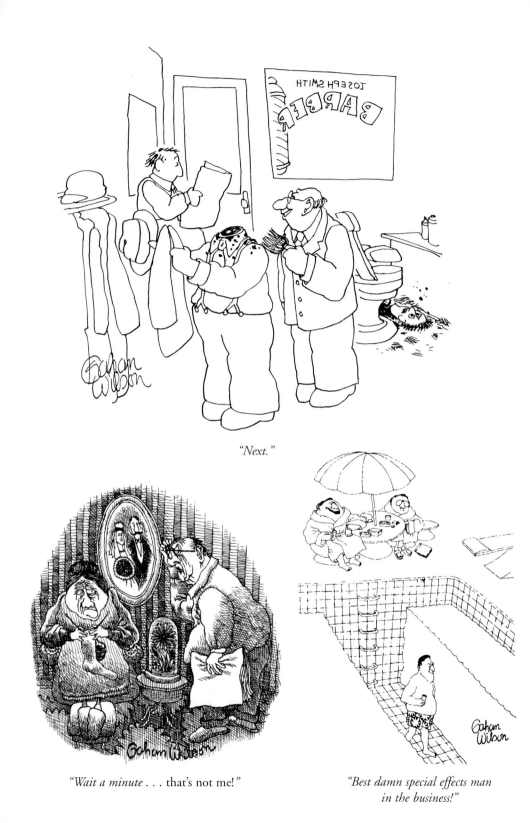

"Next."

"Wait a minute . . . that's not me!"

"Best damn special effects man
in the business!"

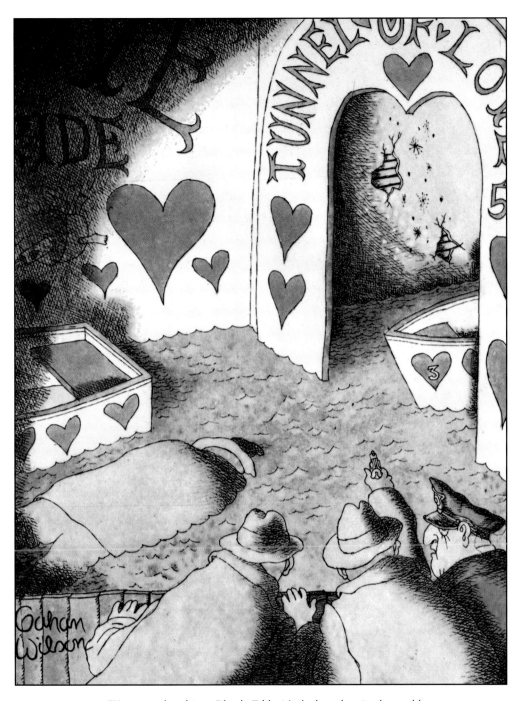

*"You got to hand it to Bloody Eddy–it's the last place in the world
you'd think of as a hideout!"*

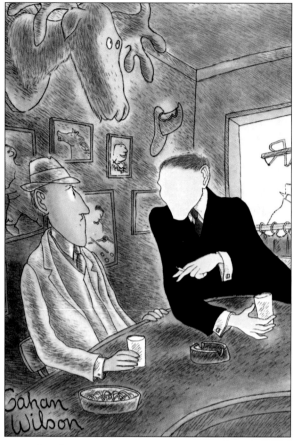

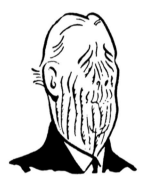

At left: Gahan pays tribute to one of *Dick Tracy's* villains. *Below:* Gahan's favorite bad guy, Pruneface by Chester Gould. *Bottom:* The Blank appeared in the Oct. 23, 1937 *Dick Tracy* strip.

PRUNEFACE
1943

"On the other hand, people always *remember my name..."*

"The *Dick Tracy* newspaper comic strip was an enormous influence on me! Chester Gould [creator of the strip] was a true master of macabre events. The blueprint clarity of Gould's drawings was great and I never failed to be fascinated by all the expressions he managed to get into his monster faces, even, I swear it, The Blank. I would nominate Pruneface as my favorite villain. Somehow Gould managed to sneak in the most awful things: bullets would go through guys, they would be beaten and bruised and burned. The comics were strong stuff!"

—*Gahan Wilson*

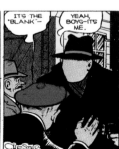

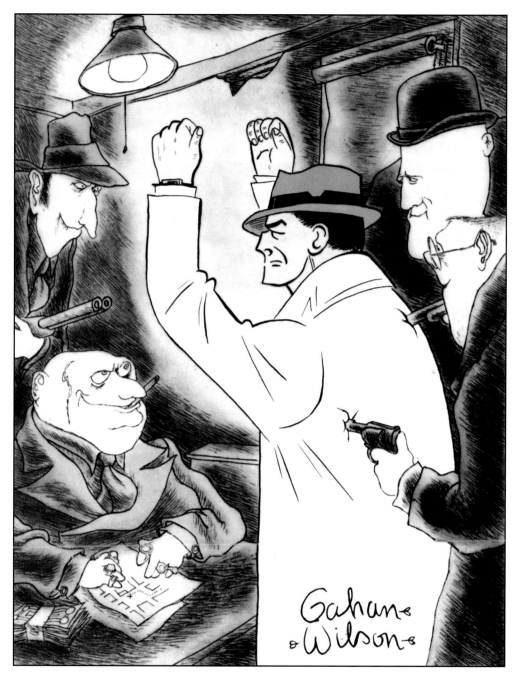

"Damn it–I told them I was too well known for undercover work!"

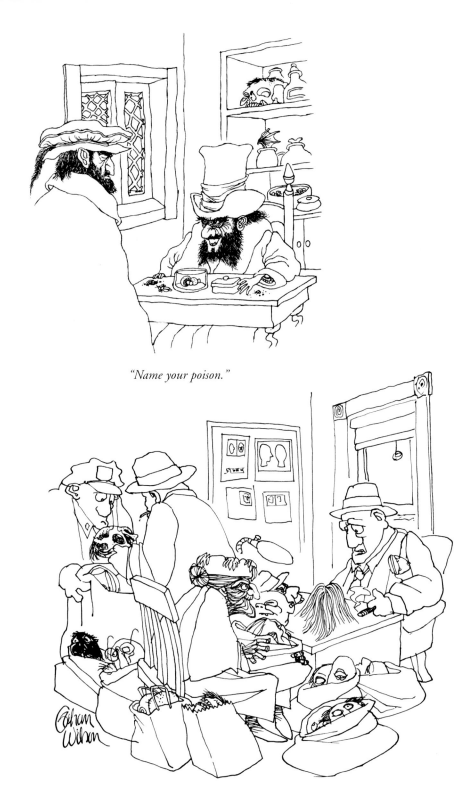

"Name your poison."

"So, when did you start your collection, Mrs. Fennerman?"

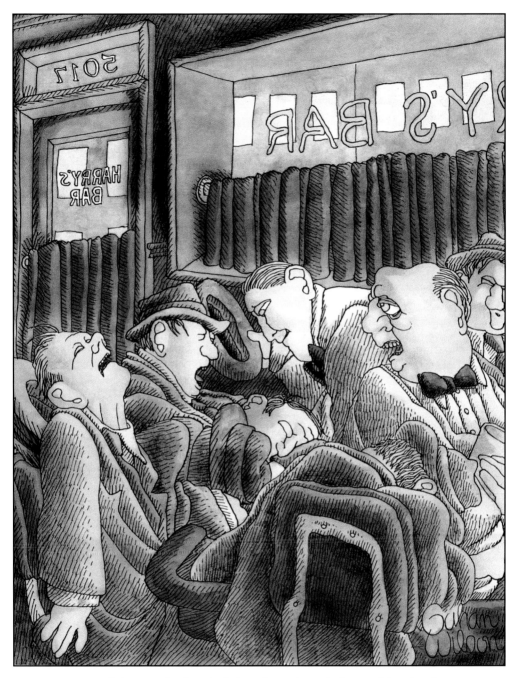

"Call the organ bank and tell them that we're ready for tonight's pickup!"

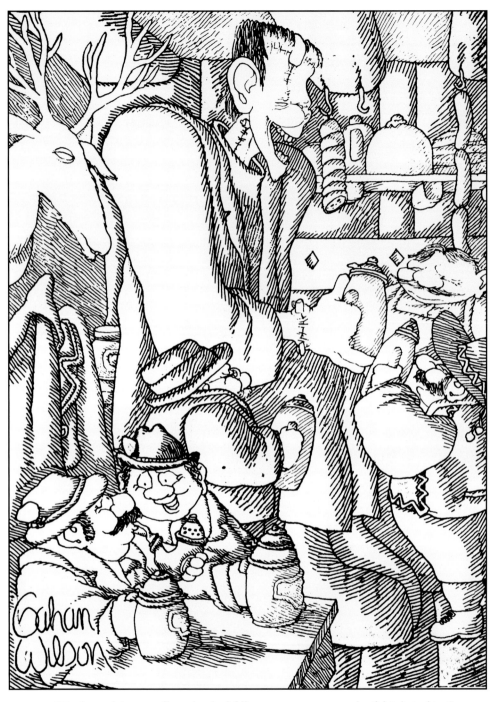

"You know, he's not really such a bad fellow once you get a couple of drinks in him!"

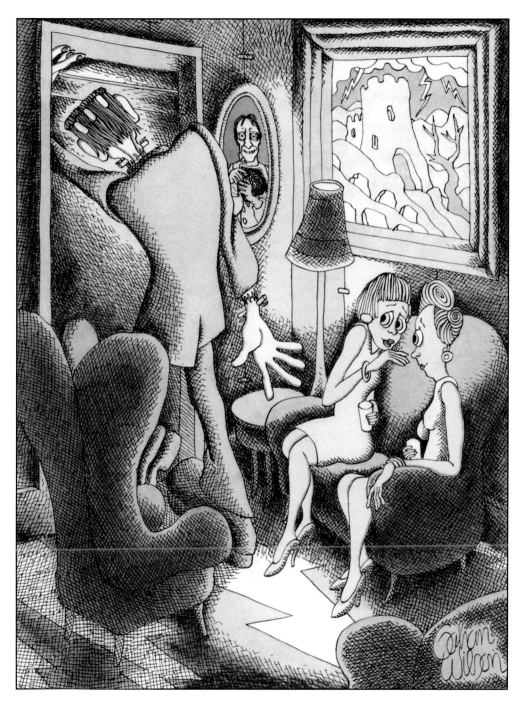

"Of course, he's into really kinky sex!"

"She's just toying with you, Parker!"

"You any idea what these stains are, sir?"

"Well, I guess that pretty well takes care of my anemia diagnosis."

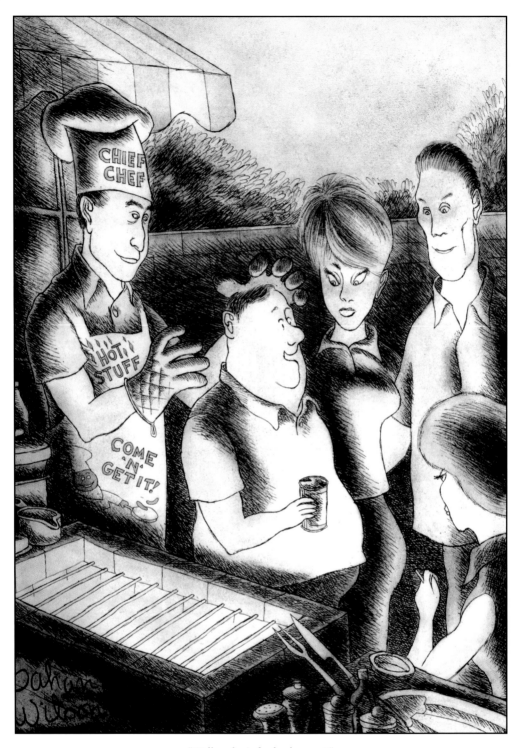

"Well...what's for barbecue...?"

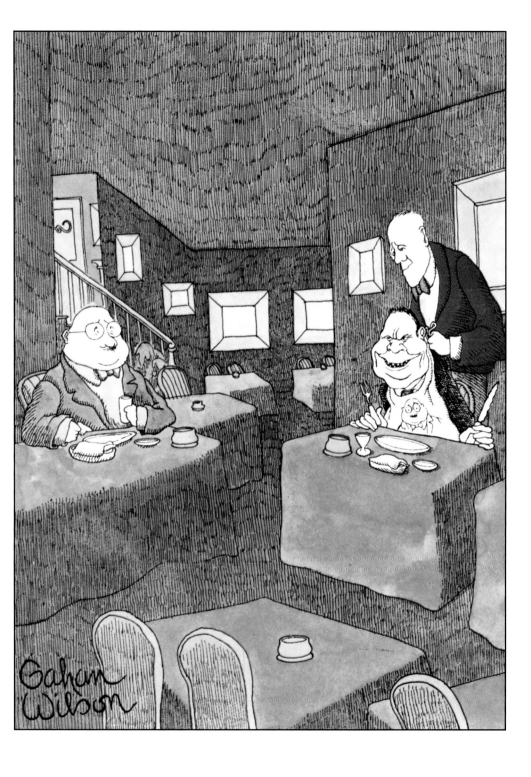

"They're offering special premiums if we use their service."

"You do this sort of thing often?"

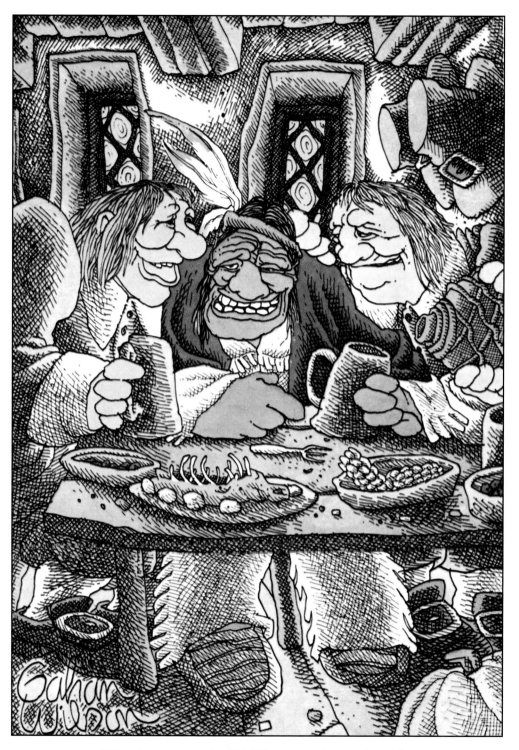

"What do you say we give Chief Wapapatame here another of those
Thanksgiving punches before talking over that little land deal?"

"Well, can you tell me when you expect
your employer to be in?"

"You use inferior materials, you get inferior demons."

"It's all the violence that does it."

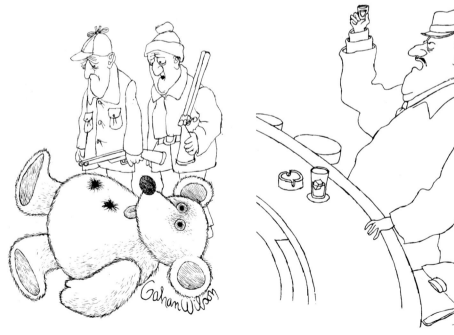

"I feel like a heartless monster!"

"To the lunatic fringe!"

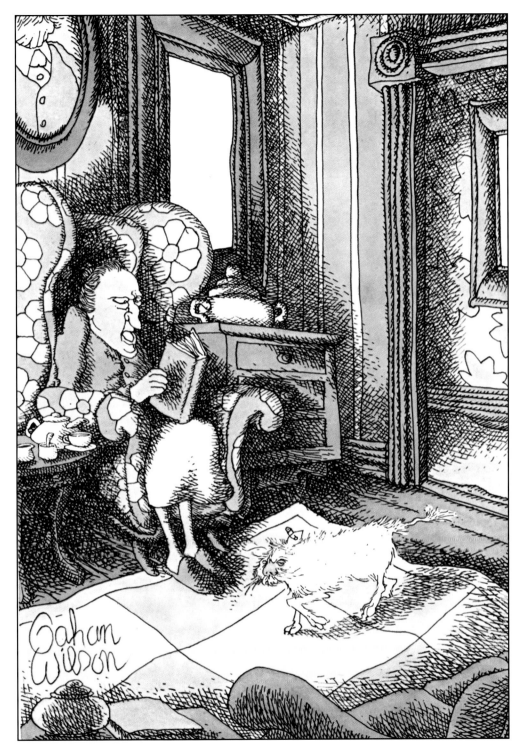

"You've been to one of those punk-rock places again, haven't you?"

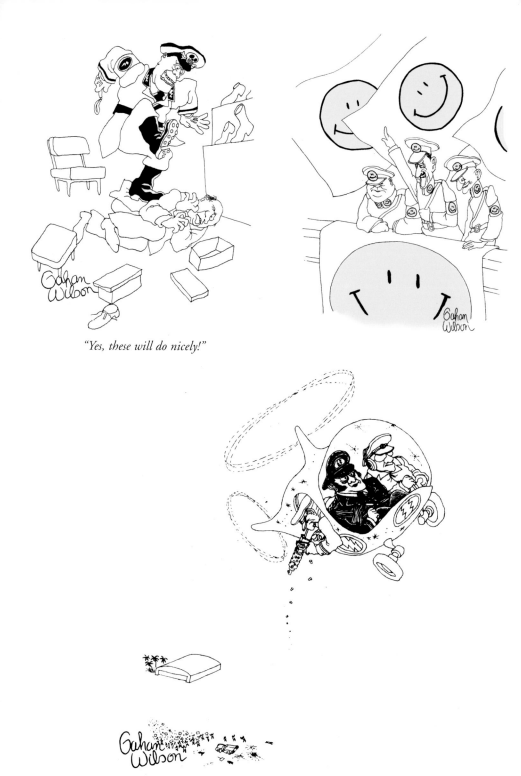

"Yes, these will do nicely!"

"My God—I've forgotten the number of my Swiss bank account!"

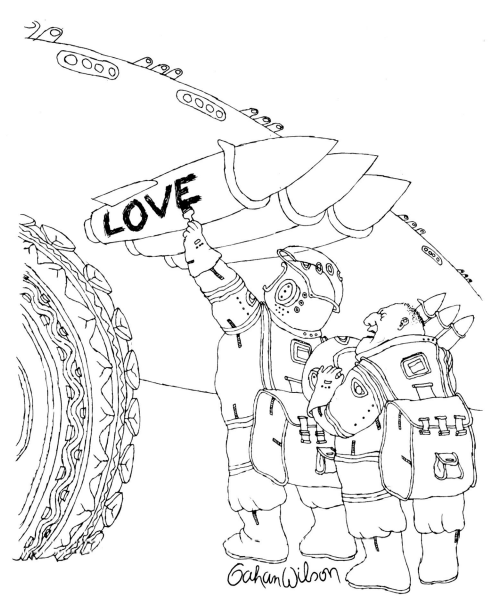

"You can't have it both ways, kid."

"Essentially I started out basing my cartoons rather heavily on classic fantasy, the Gothics new and old, but I found that life about me as reported in the news and as viewed from day to day was considerably more bizarre than anybody admitted and commonly weirder than made-up monstrosities. What was Dracula compared to Hitler? And had Frankenstein come up with anything near as sinister as Love Canal? So my stuff had become, willy-nilly, without my really intending it, more political, more of a social commentary than I'd set out to make it."

—*Gahan Wilson*

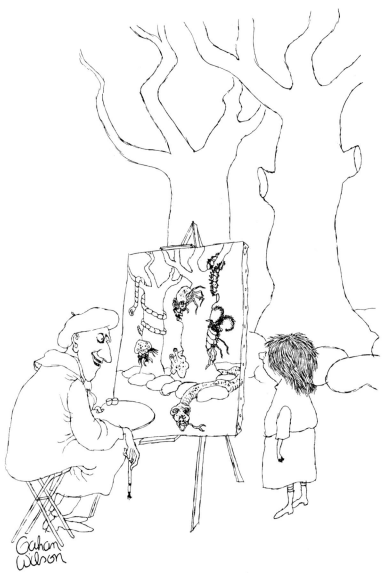

"I paint what I see, child."

"Art should lead to change in the way we see things. If some artist comes up with a vision which gives a new opening, it usually creates a lot of stress—because it's frightening. Like Cubism reveals there's this whole other reality to reality, or Stravinsky comes along and there's a riot! This is art. It's very disturbing. If you really see a Cézanne, you never see anything the same afterwards. It's heavy stuff. The creative artist is automatically an outsider, because he sees through the world that everybody else takes as the final reality and he's a very scary kind of guy."

—*Gahan Wilson*

Collection, 1971

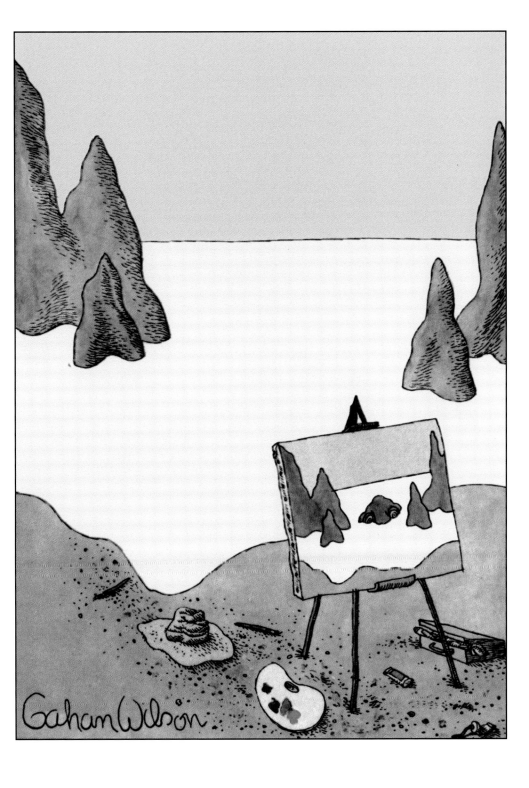

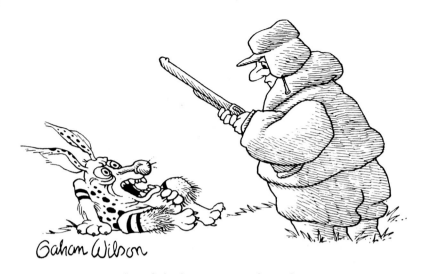

*"You fool! There's no more of me! That's it!
I'm the last of my species!"*

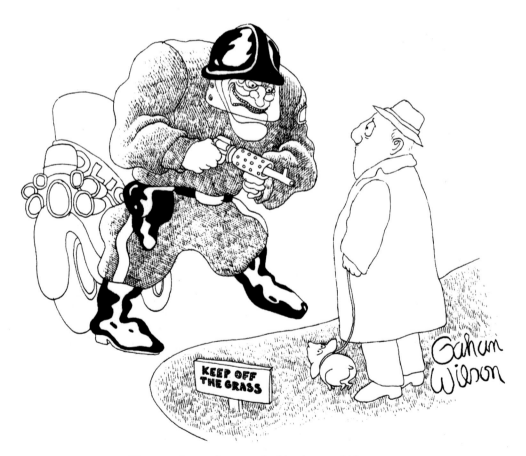

*"I'm not going to shoot you, buddy—that would be too easy.
I'm going to let you live so you can stand trial!"*

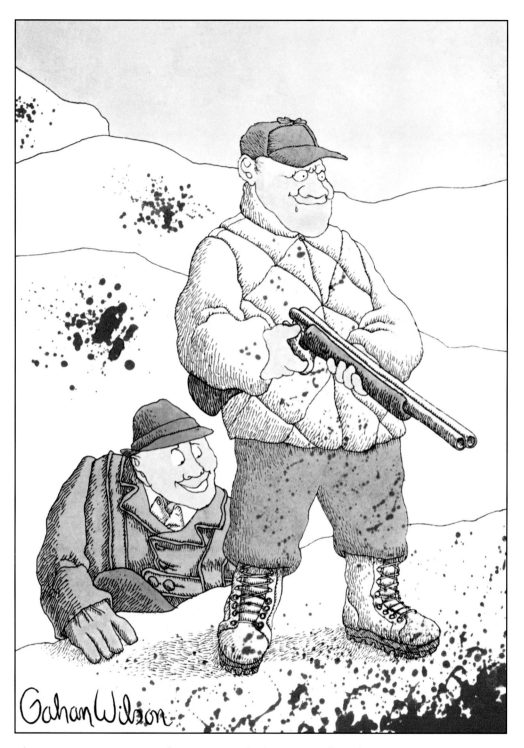

"Congratulations, Baer—I think you've wiped out the species!"

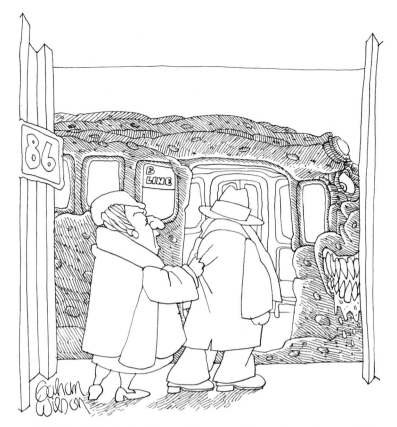

"Hold it, Fred—that's only something pretending *to be a subway train!"*

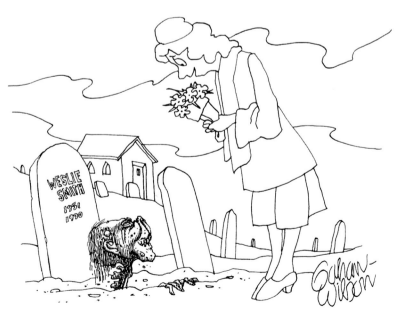

"I knew you'd be happy here, Weslie!"

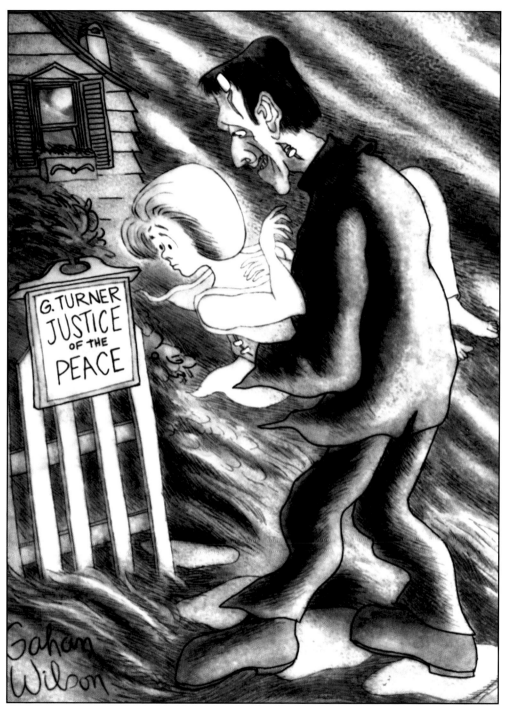

"Surprised?"

In 1969 Matty Simmons, a former Diner's Club executive and founder of *Weight Watchers Magazine*, and his business partner Len Mogel approached the trio of graduating editors of Harvard's iconoclastic magazine, *The Harvard Lampoon*, with the opportunity to put together a monthly humor publication of

December, 1977

their own with national syndication. Henry Beard, Rob Hoffman, and Doug Kenny took Simmons up on his offer and in the winter of 1970 the *National Lampoon* was born. Featuring contributions by Michael O'Donoghue, P.J. O'Rourke, Tony Hendra, Anne Beatts, and a host of other electrifying talents, the *Lampoon* became a success virtually overnight and was a magnet for

"Strange Beliefs of Childhood." August, 1973

many of the country's best humorists. It's safe to say that it was inevitable that Gahan Wilson would join their rank of creators.

"I was contacted by Henry Beard," he remembers. "I was dimly aware of Harvard's *Bored of the Rings* parody, so when Henry called I went to their offices, looked them over, saw what they were doing, and thought, 'Yeah! *This* is something I want to be a part of.' And I just dived right in.

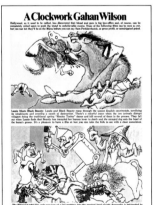

"A Clockwork Gahan Wilson." June, 1973

They were swell. The management eventually drove it into the ground by ignoring

November, 1971

the magazine and concentrating on movies and stuff to the point it all just turned into Silly Putty. Matty Simmons was mainly this ominous background presence, but the editors shielded us from him pretty much."

Wilson provided a number of features and covers for the *Lampoon* as well as a monthly comic strip during the magazine's all-too-brief "heyday."

The Paranoid Abroad

I think these people are lepers.
Cznashk dwak ekaki bor shlek.
Sooz-nah-sak twah ah-gah-si buh slah-eek.

In pre-paration for his trip, the paranoid studies his phrase book, and sentences such as, "I have been clubbed and am bleeding profusely," and "Please send someone to my room as I am trapped and it is aflame," set him to thinking on what he knows will happen.

First, of course, the stevedores will abuse and defile his luggage.

The passage will set records for foul weather, the man in the upper berth will die after a terrible coughing fit, and the paranoid will have difficulty discouraging the man in the lower berth, who will fancy him.

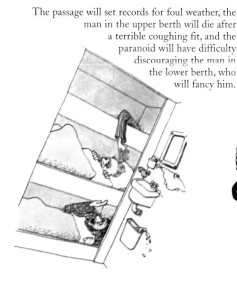

The customs officer will point out that his picture in his passport does not in the least resemble him.

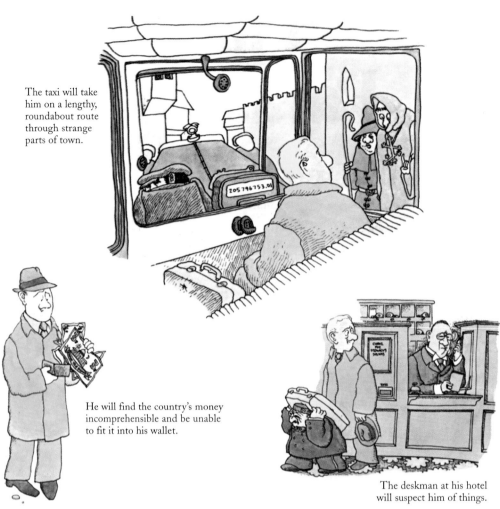

The taxi will take him on a lengthy, roundabout route through strange parts of town.

He will find the country's money incomprehensible and be unable to fit it into his wallet.

The deskman at his hotel will suspect him of things.

People will spy on him.

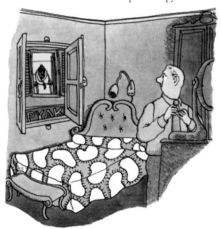

The bathroom will be full of strange devices.

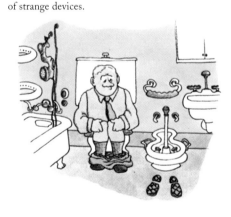

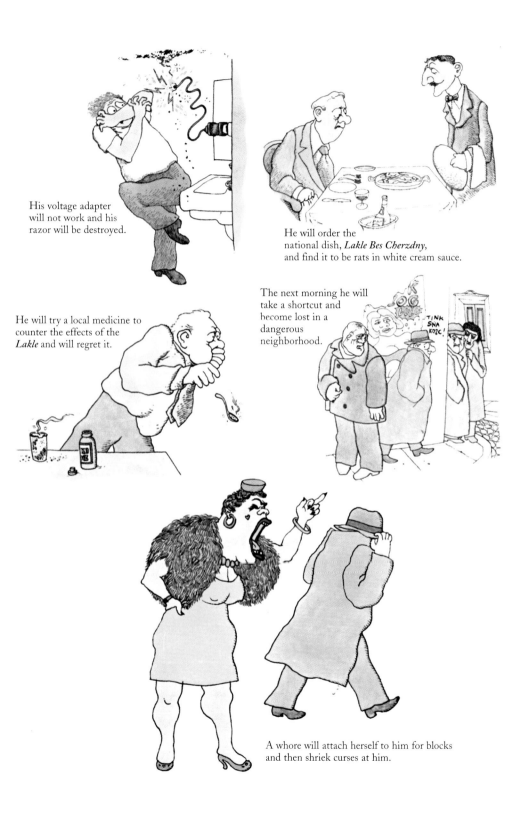

His voltage adapter will not work and his razor will be destroyed.

He will order the national dish, *Lakle Bes Cherzdny,* and find it to be rats in white cream sauce.

He will try a local medicine to counter the effects of the *Lakle* and will regret it.

The next morning he will take a shortcut and become lost in a dangerous neighborhood.

A whore will attach herself to him for blocks and then shriek curses at him.

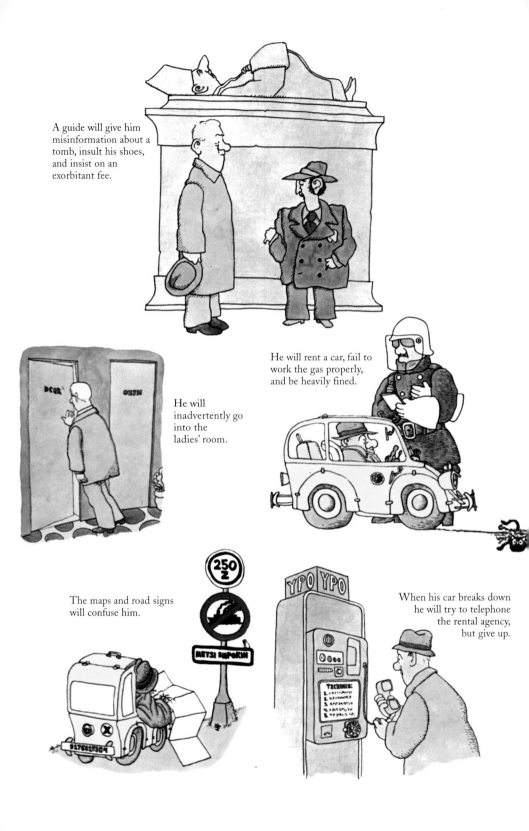

A guide will give him misinformation about a tomb, insult his shoes, and insist on an exorbitant fee.

He will inadvertently go into the ladies' room.

He will rent a car, fail to work the gas properly, and be heavily fined.

The maps and road signs will confuse him.

When his car breaks down he will try to telephone the rental agency, but give up.

In asking directions to the railway station, he will unaccountably infuriate passersby.

Whereas his fellow passengers in the train compartment will find his appearance hilarious.

On the way to the airport, a small boy will offer to carry his suitcase and steal it.

Just before leaving, he will buy his sister's youngest daughter a souvenir doll, unaware that it will make obscene gestures when wound.

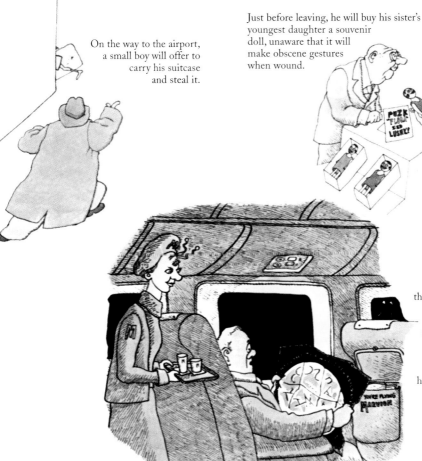

He will discover the economy flight his travel agent arranged was a serious error and that instead of returning home, his trip has barely started.

Click

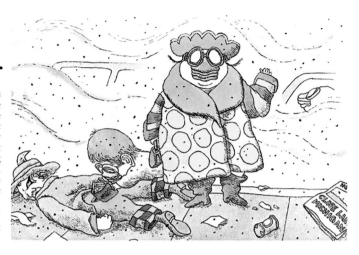

PHIL: This first slide here shows Madge and Bill standing right there in front of the New York Space Authority building, ready to start our trip. You can tell it was a pretty nice day on account they're not wearing any protective clothing except goggles and a mask. The old guy got hit by our taxi–that was some wild driver we had–and the kid's playing a trick on him. Cute, hah?

MADGE: If he hadn't of done it someone else would of. *CLICK.*

PHIL: Now this here was some lucky shot. I was going to take a picture of Billy there, when this guy steps on the Hijacker Sentinel and ow, huh? What I mean is it really got him good. I asked why it done it and they said it was on account of he looked suspicious and if you study the expression on his face you can see how they got to wondering about him.

MADGE: It turned out he didn't have no gun or bomb or anything.

PHIL: Look, all they can do is the best they can and I'm glad they got those things up there protecting us, anyways. *CLICK.*

PHIL: Well then, after we got settled in our cabin and the ship took off and all, we went up to the observation lounge and I mean they had the place really fixed up swell. No less than sixteen TV sets all going at the same time, each on a different station, of course, and a bar and every kind of a slot machine and game like that you could wish for. Back there through the window you could see the universe out there if you wanted.

MADGE: I won a whole lot of credit at the Lucky Astronaut game but I lost it all on the Zodiac Wheel. *CLICK.*

PHIL: Just a day out from Mars they announced everybody had to come and see the indoctrination lecture, and I hadn't been looking forward to that. It was something those stiffs at the United Nations had whipped up to teach you all about the Martians' customs and way of life and even their goddamn religion, for Christ's sake. But then I saw it was our social director, Earl, going to do it, and I relaxed right off.

MADGE: That Earl!

PHIL: You see, those UN creeps had given Earl a whole bunch of pictures and graphs and stuff he was supposed to teach us with, and I guess they'd bust a gut if they ever saw what he done with them. Here he is pretending to explain the sex life of a Martian, can you beat it? Only they don't have no sex life on account they haven't had any babies in thousands of years. He sure had us laughing. *CLICK.*

PHIL: Right at the space port they got these weird Martians trying to sell you pots and statues and stuff. Nothing but a lot of junk, if you ask me. Anyhow I was taking a picture of one of them when Billy did this here. It's a good thing Martians can't talk or this one here would have really given the kid a couple of bad words I bet you.

MADGE: It's not that they can't talk, it's that they've taken an oath of silence. Don't you remember the joke Earl made on that, honey?

PHIL: Well, anyhow, the way that stuff broke up, he had a nerve trying to sell it. *CLICK.*

PHIL: Right outside our hotel there, they had this wall which goes on practically forever and has all these religious pictures on it, and our guide told us a lot more than I was interested hearing about. Anyhow it's supposed to be very holy and all like that.

MADGE: That right there behind me is supposed to be the sun. *CLICK.*

PHIL: The next day we went out on a fishing trip, and here's the baby I come up with. What do you think of that, hah? They asked me did I want it stuffed and that handed me a laugh on account of where would I put it once I got it home, right? I don't think you could get it through the street out there. Then they asked me did I want some of it to eat and I told them they had to be kidding. I mean who could eat something like that, for Christ's sake, and you could smell it starting to rot. Anyhow, it was something, my catching it, cause there's hardly any of them left. *CLICK.*

PHIL: Now this was a really terrific place and the fellow who run it one of the funniest fellows you'd ever care to meet. A really swell souvenir shop and we bought a whole bunch of stuff there. You saw that thing in the bathroom, hah? What'd you think of that? And a whole bunch of other stuff, too.

MADGE: That's Billy there, wearing the mask. He got sick in it on the flight back. What a mess.

PHIL: Anyhow, that fellow that run the souvenir shop was hell of a funny guy. *CLICK.*

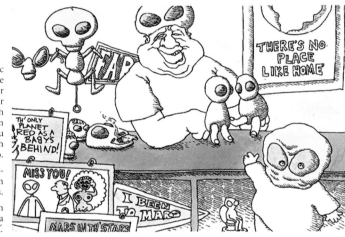

PHIL: So on the last day of the tour they took us to the Holy City there, which was out in the desert away from the town. There were these Martians at the entrance playing what was supposed to be a song of greeting, our guide told us, but it sounded to me more like a bunch of cats in heat, right, Madge?

MADGE: I had to laugh. *CLICK.*

PHIL: Speaking of laughing, here's Mr. Parker again. Seemed to me he was always laughing at something or other.

MADGE: Sometimes he'd laugh at nothing at all.

PHIL: Well here he is fit to bust on account he can't break off any of these statues right. I don't know how many he tried, must have been at least twenty, but he never did get one to break at the feet like he wanted to.

MADGE: He was going to make it into a lamp stand.

PHIL: See the stone they use there is very porous and light and what with the gravity and all being what it is you can make like Superman. Really a lot of fun. *CLICK.*

PHIL: Here's Billy, pushing over a whole, entire wall! Hard to believe, isn't it? Boy, that kid really went to town. Oh yeah, and this picture cleared up a little mystery we had all the way on the flight back which was: whatever happened to Mr. Parker, and if you look down at the left-hand corner of the picture there you can see what happened to him.

MADGE: Billy mustn't have seen he was there. *CLICK.*

PHIL: So here's Madge and Billy and we're all leaving the Holy City and Mars and I'm not ashamed to tell you we were a little choked up, you know? And it wasn't just the dust and all, it was knowing we'd probably never live to see Mars again.

MADGE: Now, Phil . . .

PHIL: No, it's true, Madge–hell, we might as well admit it. We're not kids anymore. That was our last chance. I just wish we'd done more while we were there.

MADGE: There's always Billy, dear.

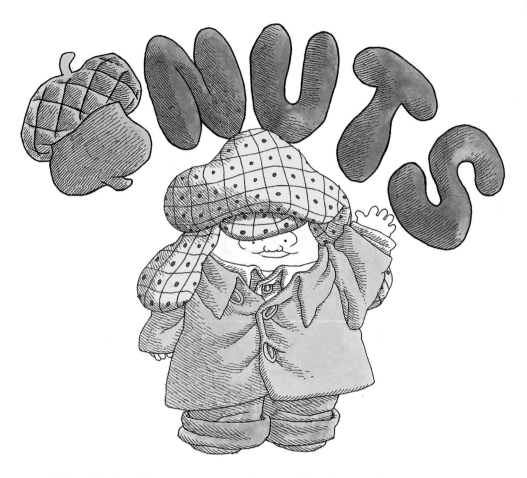

When Michael Gross became art director of the *National Lampoon* he came up with the idea of running a regular comics feature in the rear of the magazine under the collective title of 'The Funny Pages.'

"They wanted to have a little comic strip section at the end, so they wanted me to do something shocking," Wilson reveals. "I said, 'Sure! You betcha!' They probably expected me to do something involving mad scientists or vampires, but I thought, what's the most horrible thing in life? Well, growing up! That was it. My formula was the simplest in the world. I would rack my brains for things that happened to me as a kid that were so awful, I had never told anyone out of sheer embarrassment—no one, not my wife, not my best friends, no one! Of course, everyone recognized what I was getting at with 'Nuts,' that the Great Joke in life is that there *are* no secrets; we all share a common experience. 'Nuts' was my cranky reaction against the archetypal, totally unchildlike beings in *Peanuts*. Charles Schulz was really doing a kind of medieval religious pageant. All the *Peanuts* kids represent Man and Woman encountering this, that, and the other—it had nothing to do with children. So 'Nuts' was saying, 'This is the nitty-gritty, folks. This is what it's like being a little kid.'

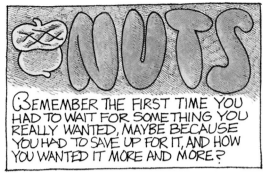

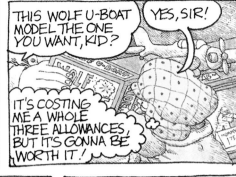

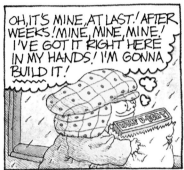

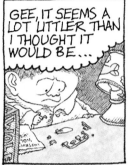

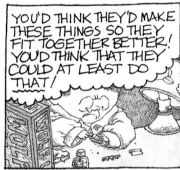

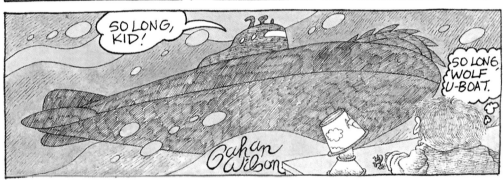

"I used the acorn in the logo as a pun, as an exclamation, and as a symbol: no easy task for an acorn to grow up into a big, old oak. The other symbol is this hat of his: it's based on Sherlock Holmes' hat, because The Kid is trying to figure it out. 'The Kid' never had any name at all, also very much on purpose. I didn't want to nail him down. He had to be universal to be effective, and it turned out—considering the longevity of the strip—people seemed to feel he *was* universal. I still have people coming up to me asking how I knew about this or that childhood experiences they had!

"I got into a dispute with the *Lampoon* because they had sold stuff of mine abroad without my permission. We got into a big fight, so I killed The Kid off. He got sick in the last strip I did for them and the tease comment in the final panel was 'What next?' And that was the end."

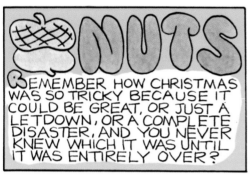

NUTS

REMEMBER HOW CHRISTMAS WAS SO TRICKY BECAUSE IT COULD BE GREAT, OR JUST A LETDOWN, OR A COMPLETE DISASTER, AND YOU NEVER KNEW WHICH IT WAS UNTIL IT WAS ENTIRELY OVER?

I GUESS IT'S LATE ENOUGH SO I CAN GET UP WITHOUT MAKING A FOOL OF MYSELF...

I WONDER IF THEY GOT ME THE CIRCUS? GOD KNOWS I DROPPED ENOUGH HINTS.

WHAT THE HELL'S THAT RACKET?

JEEZ, I WONDER IF I DID THAT ON PURPOSE TO WAKE THEM UP?

WHAAAAA

WE THOUGHT YOU COULD USE SOME NEW SHORTS.

THANK YOU.

I WONDER IF THE CIRCUS IS IN THAT ONE...

THANK YOU FOR THE ORANGE BLOSSOM PERFUME, DEAR.

YOU'RE WELCOME.

I CAN'T STAND THIS!!!

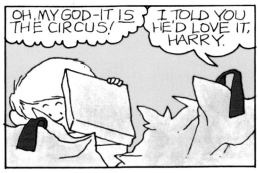
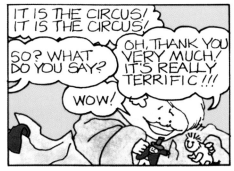
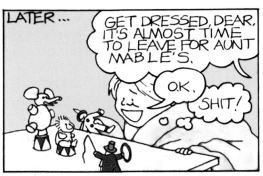
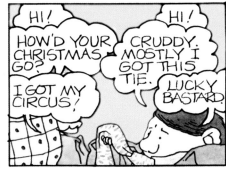
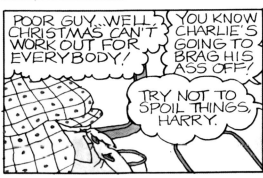
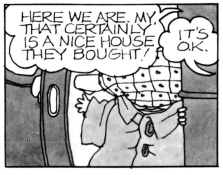
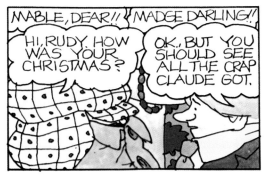
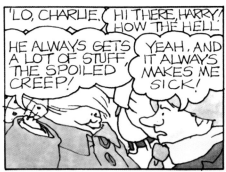

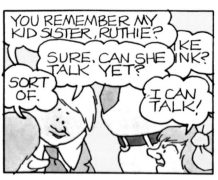

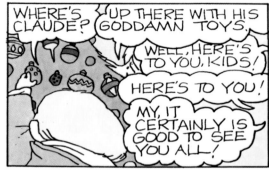

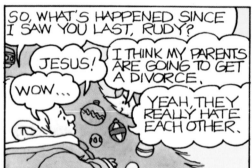

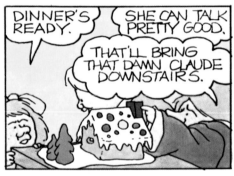

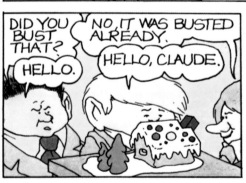

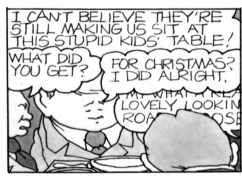

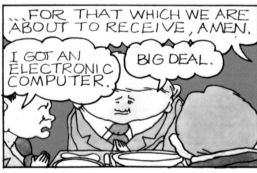

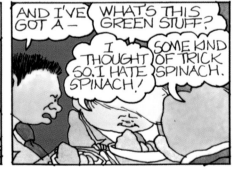

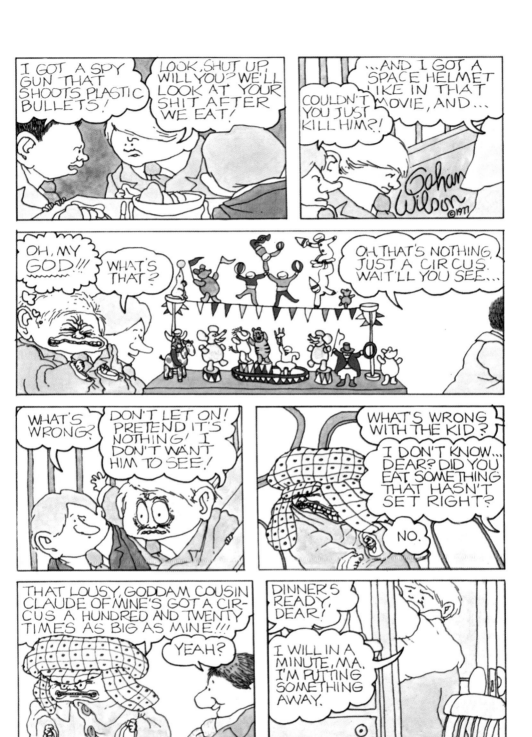

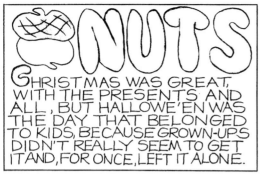

NUTS

CHRISTMAS WAS GREAT, WITH THE PRESENTS AND ALL, BUT HALLOWE'EN WAS THE DAY THAT BELONGED TO KIDS, BECAUSE GROWN-UPS DIDN'T REALLY SEEM TO GET IT AND, FOR ONCE, LEFT IT ALONE.

ALRIGHT, CLASS, NOW WE SHALL WORK ON HOW WE USE WORDS. COME UP HERE, HENRY.

YES, MISS SPATE.

THE SENTENCE READS, "THE GHOST SAID BOO." WHICH OF THE WORDS IS THE VERB?

GHOST? NO.

BOO? NO.

THE? NO.

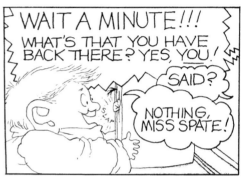

WAIT A MINUTE!!! WHAT'S THAT YOU HAVE BACK THERE? YES, YOU!

SAID?

NOTHING, MISS SPATE!

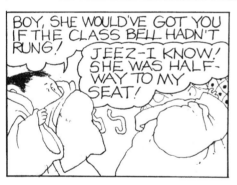

BOY, SHE WOULD'VE GOT YOU IF THE CLASS BELL HADN'T RUNG!

JEEZ-I KNOW! SHE WAS HALF-WAY TO MY SEAT!

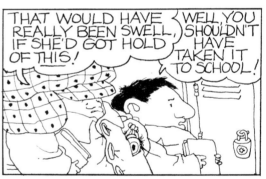

THAT WOULD HAVE REALLY BEEN SWELL, IF SHE'D GOT HOLD OF THIS!

WELL, YOU SHOULDN'T HAVE TAKEN IT TO SCHOOL!

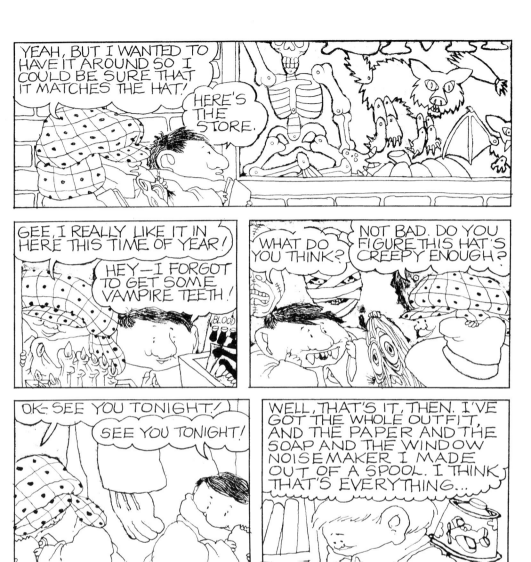

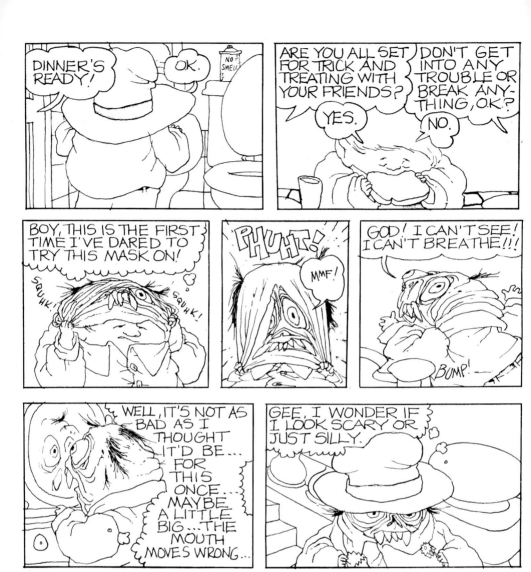

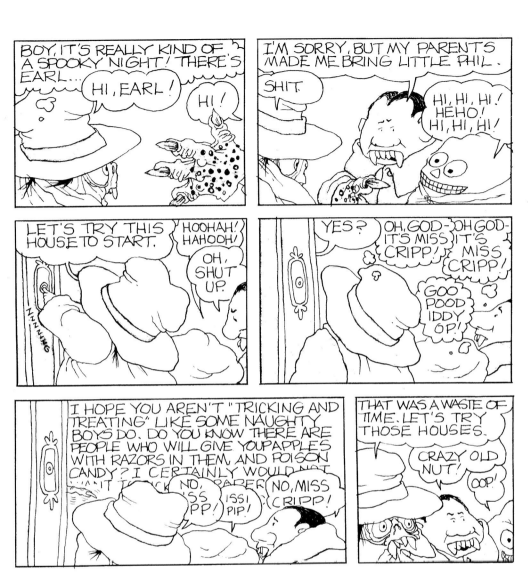

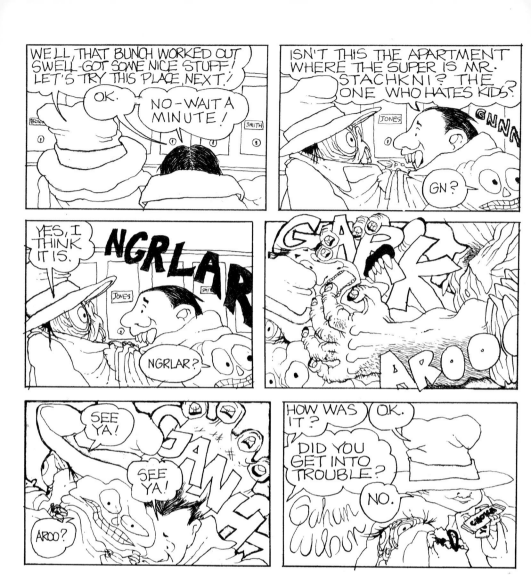

ONE HANDY THING ABOUT BEING A KID WAS THAT YOU WERE VERY CLOSE TO OTHER KIDS AND YOU COULD UNDERSTAND HOW THEIR MINDS WORKED.

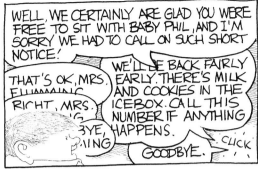

WELL, WE CERTAINLY ARE GLAD YOU WERE FREE TO SIT WITH BABY PHIL, AND I'M SORRY WE HAD TO CALL ON SUCH SHORT NOTICE!

THAT'S OK, MRS. FLUMMING.

RICHT, MRS. 'G.

'BYE, 'ING

WE'LL BE BACK FAIRLY EARLY. THERE'S MILK AND COOKIES IN THE ICEBOX. CALL THIS NUMBER IF ANYTHING HAPPENS.

GOODBYE.

CLICK

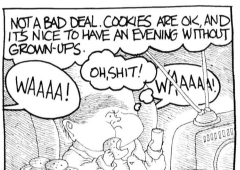

NOT A BAD DEAL. COOKIES ARE OK, AND IT'S NICE TO HAVE AN EVENING WITHOUT GROWN-UPS.

WAAAA!

OH, SHIT!

WHAAAA!

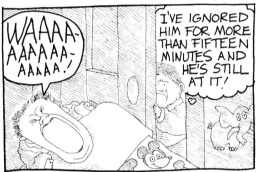

WAAAA-AAAAAA-AAAAA!

I'VE IGNORED HIM FOR MORE THAN FIFTEEN MINUTES AND HE'S STILL AT IT!

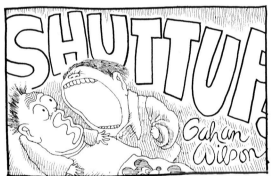

SHUTTUP!

Gahan Wilson

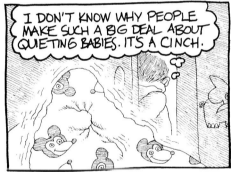

I DON'T KNOW WHY PEOPLE MAKE SUCH A BIG DEAL ABOUT QUIETING BABIES. IT'S A CINCH.

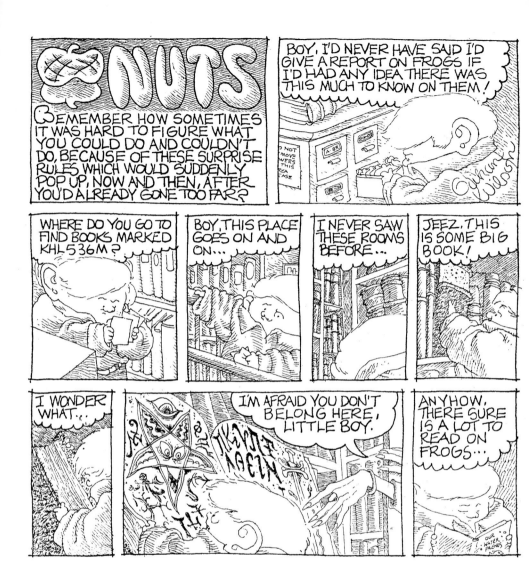

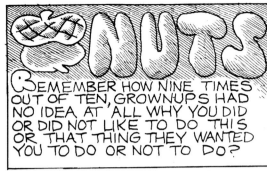

NUTS

REMEMBER HOW NINE TIMES OUT OF TEN, GROWNUPS HAD NO IDEA AT ALL WHY YOU DID OR DID NOT LIKE TO DO THIS OR THAT THING THEY WANTED YOU TO DO OR NOT TO DO?

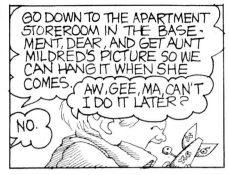

GO DOWN TO THE APARTMENT STOREROOM IN THE BASEMENT, DEAR, AND GET AUNT MILDRED'S PICTURE SO WE CAN HANG IT WHEN SHE COMES.

AW, GEE, MA, CAN'T I DO IT LATER?

NO.

CRUMBY BASEMENT!

Gahan Wilson

IT'S LUCKY FOR ME I DON'T REALLY BELIEVE THOSE THINGS EXIST!

In 1990, Wilson was approached by First Comics to illustrate the poems of Edgar Allan Poe for their *Classics Illustrated* line, which was being distributed by Berkley Books. "Unfortunately the publishers weren't good business people," Gahan explains. "First Comics was a disaster. I got paid for what I did, but there's a lot of other contributors who got stuck with unsellable complete books they had drawn and wouldn't be paid for. It was very ridiculous. Also very sad."

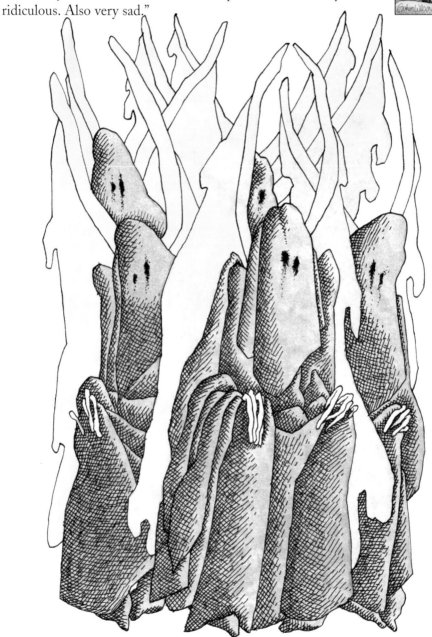

THE CONQUEROR WORM

by Edgar Allan Poe

Lo! 'tis a gala night
Within the lonesome latter years!
An angel throng, bewinged, bedlight
In veils, and drowned in tears,
Sit in a theatre, to see
A play of hopes and fears,
While the orchestra breathes fitfully
The music of the spheres.

Mimes, in the form of God on high,
Mutter and mumble low,
And hither and thither fly—
Mere puppets they, who come and go
At bidding of vast formless things
That shift the scenery to and fro,
Flapping from out their Condor wings
Invisible Woe!

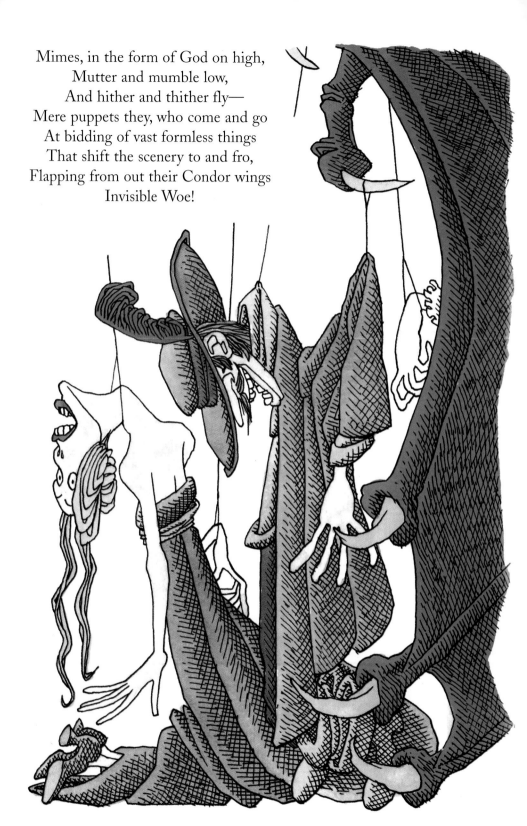

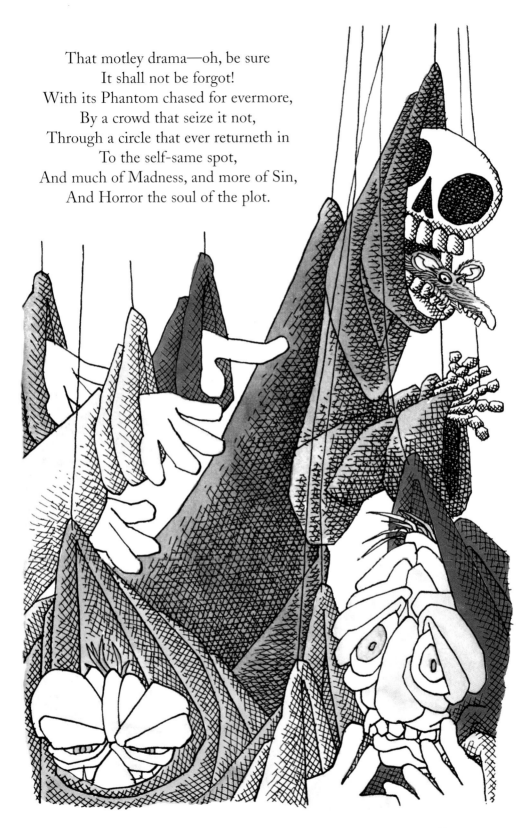

That motley drama—oh, be sure
It shall not be forgot!
With its Phantom chased for evermore,
By a crowd that seize it not,
Through a circle that ever returneth in
To the self-same spot,
And much of Madness, and more of Sin,
And Horror the soul of the plot.

But see, amid the mimic rout
A crawling shape intrude!
A blood-red thing that writhes from out
The scenic solitude!
It writhes!—it writhes!—with mortal pangs
The mimes become its food,
And the angels sob at vermin fangs
In human gore imbued.

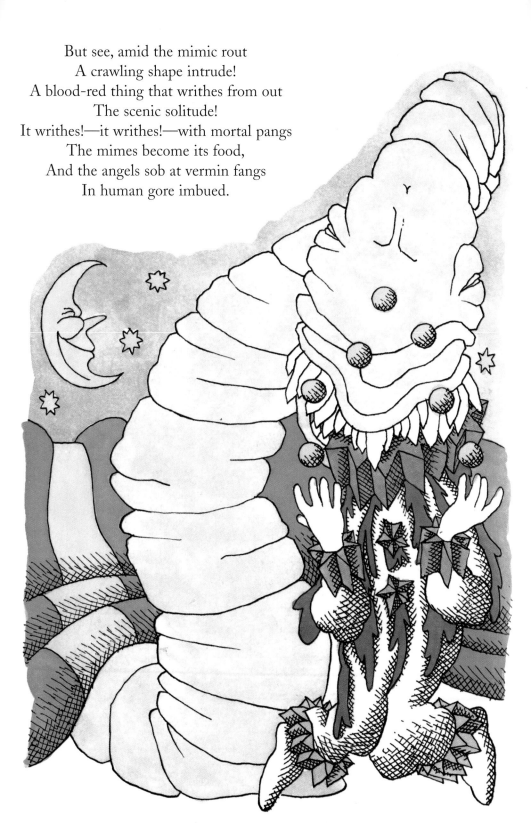

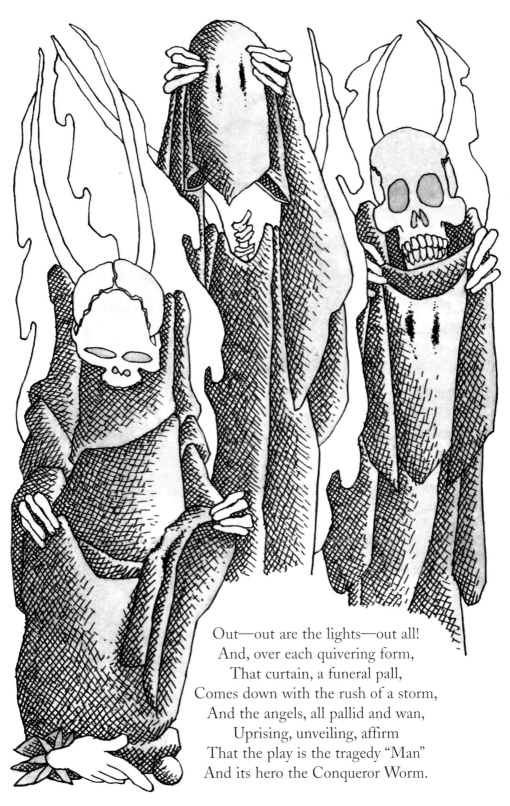

Out—out are the lights—out all!
And, over each quivering form,
That curtain, a funeral pall,
Comes down with the rush of a storm,
And the angels, all pallid and wan,
Uprising, unveiling, affirm
That the play is the tragedy "Man"
And its hero the Conqueror Worm.